FRANKENSTEIN
LIVES

"Oh! Be men, or be more than men."
—Mary Wollstonecraft Shelley,
Frankenstein; or, The Modern Prometheus

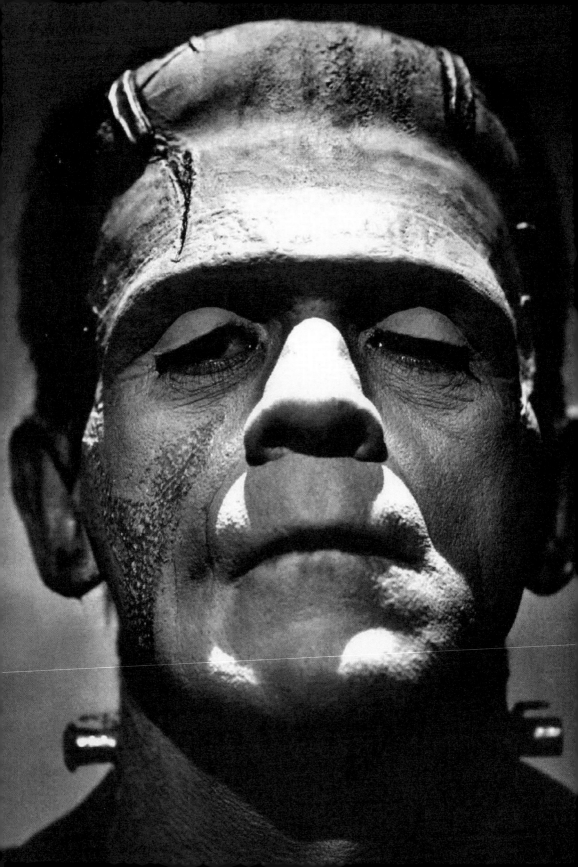

FRANKENSTEIN LIVES

THE LEGACY OF THE WORLD'S MOST FAMOUS MONSTER

PAUL RUDITIS

castle

BODY OF A BOY!
MIND OF A MONSTER!
SOUL OF AN UNEARTHLY THING!

I WAS A TEENAGE FRANKENSTEIN

starring

WHIT **BISSELL** · PHYLLIS **COATES** · ROBERT **BURTON** · GARY **CONWAY**

Produced by **HERMAN COHEN** · Directed by **HERBERT L. STROCK** · Screenplay by **KENNETH LANGTRY**

A JAMES H. NICHOLSON-SAMUEL Z. ARKOFF PRODUCTION · AN AMERICAN INTERNATIONAL PICTURE

CONTENTS

PREVIOUS PAGE: Boris Karloff as Frankenstein's monster (1931).

OPPOSITE: Poster art for *I Was a Teenage Frankenstein* (1957),
starring Gary Conway and directed by Herbert L. Strock.

INTRODUCTION

"It's alive!"

That short phrase has played a large role in pop culture. Today, people echo those words without even knowing where they originated. The line has been parodied in films, and it's even been the title of films. It has appeared on album covers, even as the name of a band. But what exactly is the *it* that is alive?

It is so much more than people might think.

It started out as Frankenstein's monster, the fictional creation that sprung from the mind of Mary Wollstonecraft Shelley and the medical manipulations of her character, Victor Frankenstein, a university student with dreams of creating everlasting life. Young Victor also came alive in the centuries since the story was first published in 1818, but he has never come close to reaching the same level of fame as the fruits of his labor.

In the beginning, *it* had no name. Frankenstein's monster was a blank slate that grew and learned and created a life for itself. It became a companion as well as a murderer, as the lonely monster turned as conflicted on the inside as the patchwork of its exterior appearance. Frankenstein's creation evolved to be more than a mere monster, but one of the most recognized fictional creations in history. *Frankenstein* grew

OPPOSITE: Actor Peter Boyle takes on the role of Frankenstein's monster in *Young Frankenstein* (1974).

beyond the simple horror story written by a teenage girl to become one of the most studied literary works and the progenitor of modern science fiction.

Somewhere along the way *it* became Frankenstein. The monster took the name of its fictional creator. It lurched into pop culture on its own and developed a new life and new mythology, shifting and changing until it bore little to no relation to Shelley's tale. It evolved to become an allegory on its own, and the source of stories that lacked monsters or mad scientists.

"It's alive!" is never uttered in Mary Shelley's work. The line was made popular by the movie that came out over a century after the story was first published. That movie is one of the key events in the monster's history that cemented the connection between the creature and the name. From that point on the monster *was* Frankenstein. It had fully taken on the name of its fictional father. Sometimes the name was meant to indicate that it was his son. Often, the name existed without the doctor even entering the picture. There have been hundreds of Frankensteins since Shelley published the original story in the early nineteenth century. Each and every one of them has come alive in its own unique way.

Frankenstein Lives explores many of these iterations, both Frankenstein's monster and the monster named Frankenstein. The character has appeared in print and in movies, as toys and on cereal boxes, with a now-familiar image that owes as much to noted horror actor Boris Karloff and makeup artist Jack Pierce as it does to Mary Shelley. But the legend of Frankenstein has grown beyond that one character, more than that one book. It has grown into an entire universe of its own, with branches in all realms of fiction and even reality. It would be impossible to catalog all the many ways it is now alive in our society, but, within these pages, we begin by examining Frankenstein: the man, the monster, and the myth.

OPPOSITE: Boris Karloff in the full iconic Frankenstein makeup.

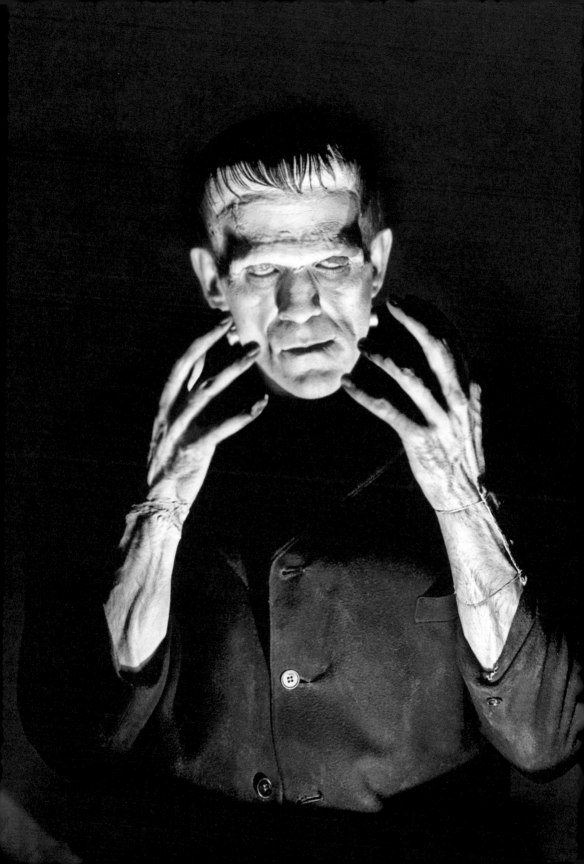

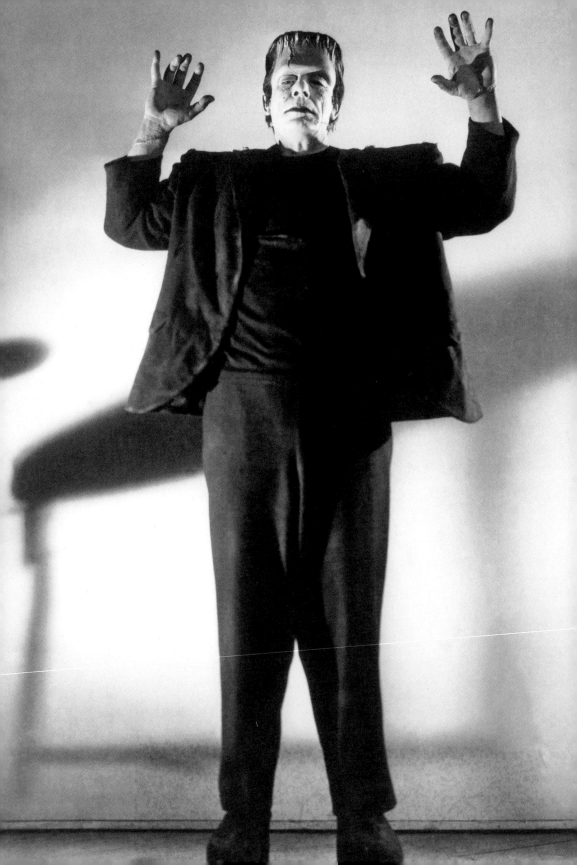

RISE OF THE MONSTER

1

On a dreary night in June of 1816, at the Villa Diodati near Lake Geneva, a group of friends and writers came up with an intriguing way to pass the time. The weather in Switzerland was miserable, as it had been for months. They'd been holed up together for several days in the rented villa, entertaining themselves by sharing ghost stories, when the de facto leader of the group, a dreamy poet, came up with a game. It was a simple challenge, a bet among friends, to craft a haunted tale of their own. That game would lead to the birth of one of the most recognized—and most misunderstood—fictional characters in history.

The dreamy poet was Lord George Gordon Byron, acclaimed writer and politician, and a leading voice in the Romantic movement in literature. Lord Byron had already authored numerous works of note, including the narrative poem that catapulted him to literary stardom, *Childe Harold's Pilgrimage*. He'd also achieved infamy by earning a reputation as "mad, bad, and dangerous to know," from a former lover. Byron had rented the villa along with his close friend, confidant, and current lover, Dr. John William

OPPOSITE: Actor Glenn Strange as Frankenstein's monster, in costume and makeup, in an undated photo circa 1940s.

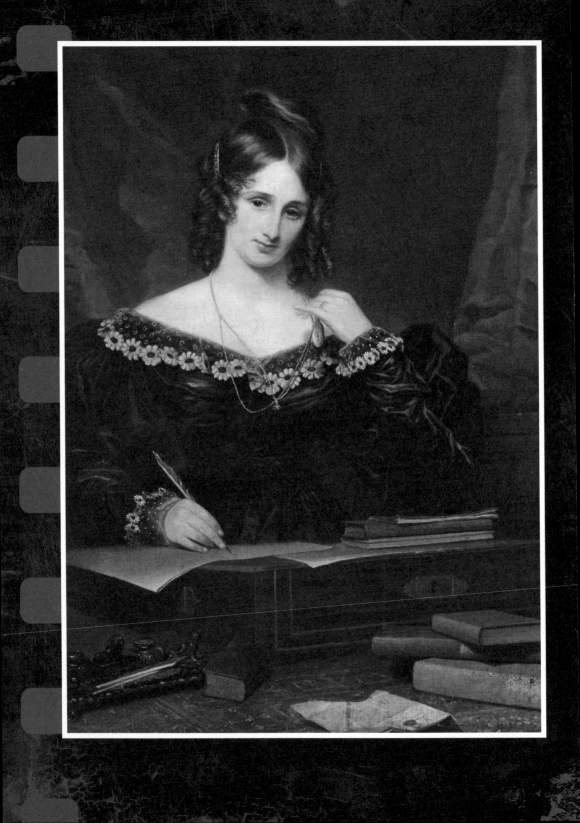

Polidori. Their guests were renting another home in the nearby village. The poet Percy Bysshe Shelley was effectively on the run, hiding out from creditors in Switzerland along with his love and her sister. His future sister-in-law, Claire Clairmont, would later bear Byron's child. But it was Shelley's paramour, Mary, who would come out of their game with a story that earned her literary acclaim.

The group was already scandalizing the locals by spending so much time shuttered away in the villa in what many felt was an orgiastic display of hedonism. Reportedly, one of the townsfolk was renting out makeshift telescopes to those hoping to catch a glimpse of the illicit happenings inside the mansion. On this night, if those watchful eyes could have seen through walls, they would have borne witness to the conception of a monster, one that is still being enjoyed and studied two hundred years later: Mary Wollstonecraft Shelley's creation, *Frankenstein*.

THE EDUCATION OF A WRITER

Mary Wollstonecraft Godwin was the child of two writers and famous nonconformists. Her father, William Godwin, had achieved notoriety through the publication of *An Enquiry Concerning Political Justice and Its Influence on Morals and Happiness*, which was considered the first publication on the subject of anarchism. Written near the outset of the French Revolution, Godwin argued that government institutions were corrupt and that the future would belong to individuals providing for their own needs rather than being subjected to their leaders' whims. Mary's mother, Mary Wollstonecraft, was the author of *A Vindication of the Rights of Woman: with Strictures on Political and Moral Subjects*, a treatise that argued women's rights should be equal to men's. It was one of the earliest works to cover a topic that would eventually give rise to feminism.

Both authors found inspiration in rebutting Edmund Burke's *Reflections on the Revolution in France*, but William and Mary did not connect romantically during their first meeting at the home of radical publisher Joseph Johnson. As William noted in a diary entry dated November 13, 1791, he had come to meet Thomas Paine, the author of *The Rights of Man,* but spent most of the evening listening to Mary speak on the subjects of virtue and religion. He summed up the encounter by noting that they left the gathering "mutually displeased with each another." It was only when they reconnected five years later that they developed a deeper affection for one another. Though neither believed in the institution of marriage, the pair wed when Mary became pregnant with what would become their only child together. The reasoning behind this move was largely pragmatic: they wanted their offspring to enjoy a legal acknowledgment that

OPPOSITE: A portrait shows Mary Wollstonecraft Shelley writing.

Mary's first child, Fanny, from an earlier affair with Gilbert Imlay, had lacked. Their union, however, would be forever tinged with sadness. Mrs. Wollstonecraft Godwin developed a postpartum infection upon the birth of their daughter and died of septicemia (blood poisoning) ten days later.

The newborn, Mary Wollstonecraft Godwin, was motherless. She would be raised by a father who was not prepared to bring up both her and her half sister, Fanny. To his credit, William recognized his deficiencies quickly and set about to deal with them. In an arrangement that seems to have come more out of convenience than affection, he remarried four years later to the former Mrs. Jane Clairmont, a woman with two children of her own. Mary would never grow close to her new stepmother. Few people did, as many of William's acquaintances found Jane unpleasant, to say the least. But the union did provide Mary with a particularly beloved stepsister and a future partner in crime. Clara Mary Jane Clairmont, better known as Claire, would be a close companion of Mary's into their adulthood.

Mary's father may not have been demonstrative in his love, but his bewilderment in raising children, particularly daughters, had at least one benefit: Mary received the kind of education that was more akin to that of boys of the age than that of her female peers. Beyond the teachings of her anarchist father, Mary was exposed to a host of writers and poets while growing up. The family home was something of a gathering spot for the literati of the early nineteenth century. Though Jane forbade the children from attending the grown-ups' events at the house, Mary and Claire once famously hid beneath the couches of their living room to listen to the poet Samuel Taylor Coleridge read passages from *The Rime of the Ancient Mariner*. It was little surprise that Mary herself began to write stories and poems as a child. She was ten when her first poem was published by a press owned by her father. Years later, she referred to writing as a favorite pastime in her childhood, and the primary way she chose to fill her hours allotted for recreation.

At fifteen, Mary was sent away to Scotland to stay with the family of noted radical William Baxter. Her visit was supposed to allow her to recuperate from an ailment credited to a nervous condition, while also partially intended to continue her

philosophical education. Though perhaps it was to get away from her stepmother, as several scholars have suggested. While away, Mary developed a relationship with Percy Bysshe Shelley, a poet and philosopher five years her senior.

Percy was something of a nonconformist, having published a pamphlet passionately extolling the virtues of atheism while studying at University College in Oxford. Percy idolized William Godwin and first met Mary after seeking an audience with her father. Though Percy was married at the time, his relationship with Mary grew while she was in Scotland, and he considered her both a romantic partner and an intellectual peer. Her father frowned upon the relationship at first, which—along with Percy's status as a married man—initially forced the pair to meet in secret. They chose the grave of Mary's mother as the spot for their rendezvous.

In 1814, Mary and Percy spent part of their summer exploring Europe, with Claire as their travel companion. Their trip would be recounted in the aptly titled *History of a Six Weeks' Tour Through a Part of France, Switzerland, Germany, and Holland*, published

ABOVE: Mary Shelley was born in 1797 at Field Place, in Horsham, in Sussex, England.

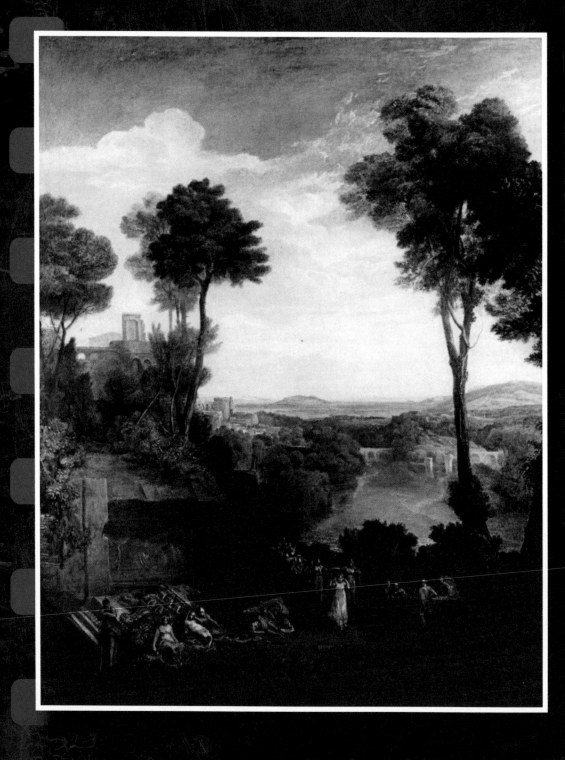

in 1817. What they saw on the trip would inspire much of the setting of Mary's future creation, the work that would make her famous.

Six months after their trip, Mary prematurely gave birth to their daughter. The child lived for only two weeks. The death reportedly drove her into a deep depression.

It was just one of many tragedies Mary faced that would impact her body of work. Her own mother's death shortly after she gave birth to Mary weighed heavily on Mary throughout her life, as did her first child's death. Scholars have long discussed the influence both losses had on Mary and what it might have inspired in her story in which a man plays the role of god by creating life, then abandons that life, which goes on to haunt him for the rest of his days.

Mary gave birth to another child, William, early in 1816, and soon after, the little family began a second tour of Europe, with an extended stay in Switzerland. Again, Claire was their traveling companion, and they rented a small house near the Villa Diodati. Percy was still legally married to Harriet Westbrook, though it was rumored that his estranged wife was in a relationship with another man. Either way, Percy's closest friends—including Byron and Polidori, at Villa Diodati—had already started referring to Mary as Mrs. Shelley.

TELLING TALES

At their villa in the Alps, when the friends weren't busy scandalizing the locals, they were taking turns reading tales from *Fantasmagoriana*, a French collection of German horror tales. Byron proposed that the group have a friendly competition: everyone would create their own stories of the macabre. The challenge was accepted, though with varied interest and accomplishment. Claire seemingly bowed out from the start. Byron was already at work on the third canto of his narrative poem *Childe Harold's Pilgrimage* and likely was distracted by his larger project. His contribution to the contest resulted in a "fragment" of a poem eventually published as an addendum to a larger piece. Only Polidori and Mary produced fully fleshed-out stories that would prove to be significant entries in the Gothic Horror movement, with Mary's having the larger impact by far.

The challenge couldn't have been more aptly timed, as Mary Shelley recounted in her introduction to the third edition of *Frankenstein*, released in 1831. The passage has been reproduced many times since its first printing and has been reviewed and studied by students and professors, alongside with Mary's and Percy's journals and her early

OPPOSITE: *Mercury and Herse* (1811) by J. M. W. Turner is a prime example of his imaginative landscapes. Later, the artist depicted what Shelley called Geneva's "wet, ungenial summer" following the eruption of Mount Tambora in Indonesia in 1815.

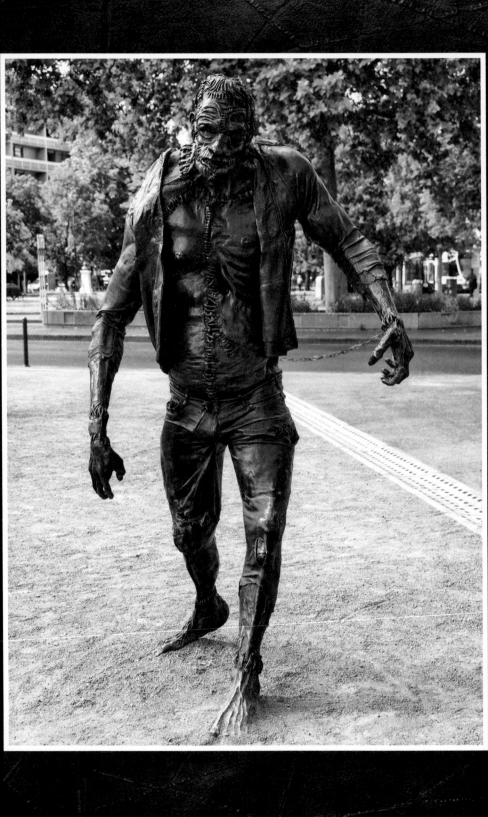

Creation Tales

Frankenstein has become so enmeshed in pop culture that even the story of its initial creation has inspired tales both romantic and horrific. The challenge between the writer friends has been recounted numerous times over the years. It's a perfectly wonderful anecdote about the genesis of one of history's most recognized characters. That dreary night has been re-created in several supposedly biographical films based on the lives of the characters in that scene, but it has also inspired new stories that bear not even a passing resemblance to reality.

The scene was memorably rewritten for the opening to the 1935 film *The Bride of Frankenstein*, where it serves as an introduction to the movie. Mary Shelley, as played by Elsa Lanchester, basks in the compliments of her two male companions—Percy and Byron. The men are applauding her for the tale of Frankenstein, which she has already written in this revised telling of the historical event. The setup serves to introduce the sequel to the 1931 *Frankenstein* as if it is simply an unpublished continuation of Mary's original novel. In truth, the movie does include scenes clearly inspired by her existing novel, but this bride for the monster never actually appears in Mary's work, even though the idea of a female companion occupies a good portion of the text.

The 1986 film *Gothic* takes a deeper, and even more fictional, look at the events of that night. In the horror movie, with Natasha Richardson in the role of Mary Shelley and Gabriel Byrne as Lord Byron, the players reveal their darkest secrets. A séance is performed, awakening a malevolent spirit that haunts the villa, torturing them with their deepest fears. The tragedies that would befall the members of the party—with the premature deaths of Percy, Byron, and Polidori, as well as the future deaths of Claire's and Mary's children—are implied to be the result of this haunting.

Based a bit more in reality, but still fictional, are two films released in 1988. Both are centered on that night in 1816. *Haunted Summer*—with Alice Krige in the role of Mary and Eric Stoltz as Percy—is a psychological thriller, with the characters engaged in the kind of behavior the local villagers would have loved to witness through their makeshift telescopes. And *Rowing with the Wind*, starring Hugh Grant as Lord Byron, expands beyond the competition to follow Lizzy McInnerny's Mary Shelley through the next six years of the author's life as *Frankenstein* is published and tragedy befalls those she loves.

OPPOSITE: *Frankie a.k.a. The Creature of Doctor Frankenstein* is located in the heart of Geneva, an appropriate bicentennial tribute to Shelley's famous novel.

drafts of the book. These companion documents to the original manuscript and its follow-up versions have also been dissected by academics for almost two centuries.

The contest was initiated during what has become known as the "Year Without a Summer," following the eruption of Mount Tambora in Indonesia on April 10, 1815. The volcanic event was the largest eruption in modern history, killing over seventy thousand people. It sent so much ash into the air that it impacted global weather patterns, causing a "volcanic winter" by blocking out the sun, which led to dropping temperatures worldwide. Over the next year, crops failed, causing animals and people to suffer and die. It was also during this time that Frankenstein's monster was born.

The volcanic winter of 1815 stretched into summer of the next year. While Mary wrote of spending time on Lake Geneva, she also acknowledged in her preface that it was a "wet, ungenial summer" trapping them at home for days at a time. It was a suitable setting not only for telling ghost stories but for drawing one up as well. Certainly, the dreariness of that summer can be seen in the tale. Much of *Frankenstein* is set during conditions in which a "noble war in the sky elevated [Frankenstein's] spirits" until the creature's form is revealed to its creator through a flash of lightning.

Mary set to work on Byron's challenge with determination, hoping to "make the reader dread to look around, to curdle the blood, and quicken the beatings of the heart." In her introduction to the third edition, she reports that she struggled for days to come up with something. During that time, she also listened to long conversations between her male companions on such topics as the possibility of discovering "the nature of the principle of life," Dr. Charles Darwin's work, and the possibility of reanimating the dead. These conversations stayed with her. As she lay down to sleep one night, she could not find rest; there was a waking nightmare lurching through her mind, thoughts that would give form to arguably the most famous manmade monster in history. As she recalls in her introduction:

"I saw—with shut eyes, but acute mental vision,—I saw the pale student of unhallowed arts kneeling beside the thing he had put together. I saw the hideous phantasm of a man stretched out, and then, on the working of some powerful engine, show some signs of life, and stir with an uneasy, half vital motion. Frightful must it be; for supremely frightful would be the effect of any human endeavor to mock the stupendous mechanism of the Creator of the world. His success would terrify the artist; he would rush away from his odious handy-work, horror-stricken. He would hope that, left to itself, the slight spark of life which he had communicated would fade; that this thing, which had received such imperfect animation would subside into dead matter; and he might sleep in the belief that the silence of the grave would quench for ever the transient existence

of the hideous corpse he had looked upon as the cradle of life. He sleeps; but he is awakened; he opens his eyes; behold the horrid thing stands at his bedside, opening his curtains, and looking on him with yellow, watery, but speculative eyes."

Victor Frankenstein emerged from Mary's waking dream, and from that fictional creation came the monster that would eventually adopt his creator's name and become the pop culture phenomenon.

ENTER THE DAEMON

Mary Shelley's waking nightmare grew into *Frankenstein; or, The Modern Prometheus*. In it, she created a pair of characters who would impact the literary world in a profound way and who would live on and influence pop culture for centuries. Only Sherlock Holmes, Tarzan, and Dracula have appeared more often in media than Frankenstein's monster. Shelley's creation was no small feat for a nineteen-year-old in an era when women did not receive much respect for their work. As it happens with legends, Mary's original story grew to take on new and different forms. Like any game of telephone, some of these incarnations bear no

ABOVE: The first page (of Vol. II) from the original manuscript of *Frankenstein; or, The Modern Prometheus* by Mary Shelley.

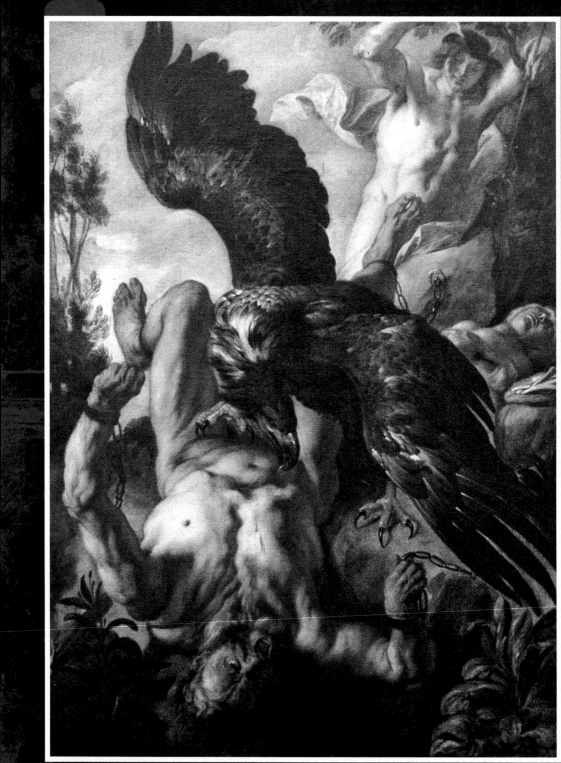

resemblance to the source material. But the novel itself continues to be studied two hundred years later.

Mary spent the rest of that dismal summer piecing together her story. The tale grew to incorporate themes personal to her. A man plays god by creating life in his own image. It's a story, effectively, about a relationship between parent and child, and it is infused with her own experiences having lost a child and never knowing her own mother. She introduced this very subject into her narrative with the character of Elizabeth, Victor's cousin, who comes to live with the Frankenstein family after her own mother dies.

Frankenstein; or, The Modern Prometheus opens as an epistolary, with the narrative introduced in a series of letters written by R. Walton to his sister, Margaret Walton Saville, who, as scholars have pointed out, shares Mary Wollstonecraft Shelley's initials. Walton is not the protagonist though. He is more of a conduit for the story, passing it along from the original storyteller to the audience as the text shifts to a more traditional narrative.

The Frankenstein in Mary's original tale is not the monster. Nor is he a mad scientist, locked away in a foreboding castle. Victor Frankenstein (whose first name matches a pseudonym often employed by Percy) is a young student who toils away in secret while studying at the University of Ingolstadt, an actual educational institution that had closed well over a decade before Mary wrote her tale. The school specialized in radical science. The faculty educated freethinkers, and the school gave birth to the Illuminati, a secret society that fought against the corruption of power in government and the influence religious institutions held over the public at large. Mary's modern-day (of the nineteenth century) Prometheus does not sculpt man from clay but rather from body parts scrounged from morgues and cemeteries around the town. The creature that Frankenstein breathes life into is large and deformed, but does not have bolts in his neck or a flattop head. Those would come later.

Frankenstein's creation is often referred to as a monster in the original text, but it is also known as "the daemon." The title may be fitting considering its murderous behavior in the story, but not quite fair considering it is Frankenstein's godless act that brings that daemon to life. Much has been made of the themes of *Frankenstein* centering on the dangers of a man obsessed and science running unchecked. The mad scientist secreted away in a remote castle has become one of the prime images associated with

OPPOSITE: Prometheus was punished by Zeus for stealing fire from Hephaestus to give to man. In this 1640 painting by Jacob Jordaens, titled *Prometheus Bound*, Prometheus is shown chained, while an eagle pecks out his liver. Each night the liver regenerated.

the tale. But *Frankenstein* is also the story of a weak man, so horrified by his creation that he'd rather ignore that life than confront his truth. Victor's habit of taking ill when he is overwrought rather than facing the situation head-on—especially when his loved ones are in danger—is a much more prevalent theme, reflecting Mary Shelley's dream in which "he would rush away from his odious handy-work, horror-stricken."

Victor first takes to his sickbed when he realizes that he has given life to a physical abomination. The daemon is like any child, unable to speak or truly comprehend the world around him. In Victor's absence, it flees its secret laboratory home and sets out to explore a world in which its deformities make it a monster, a world with humans who attack on sight. But the daemon begins to evolve by observing those humans. It learns to speak and to read, ultimately growing to be as intelligent as its creator, and somewhat more sensitive and philosophically aware. But it is a solitary life, where almost everyone it meets reacts in horror. It kills accidentally, and then on purpose, targeting Victor's loved ones after being rejected by him, its creator. All the while, that weak-willed creator does very little to stop the killings, or even speak up to save those innocently blamed for the daemon's actions.

The daemon threatens Frankenstein, forcing him to create a second abomination, a female companion to ease its loneliness. Though Frankenstein goes through the motions of the request, he cannot complete the task of bringing this potential "bride" to life. This intensifies the battle between man and monster, ultimately bringing it to its end. Both sides in the conflict lose. Frankenstein dies, without ever taking responsibility for his actions. But it is the daemon that experiences the most growth, mourning the loss of its creator while facing a life of exile from humanity.

THE MONSTER LET LOOSE IN THE WORLD

With a completed story of roughly twenty thousand words, Mary set to revisions in the fall of 1816. Percy served as her editor and grew even closer to her along the way. Percy's contributions to the tale would take on a life of their own, adding to an authorship controversy that exists to this day. Some believe that it was actually Percy who wrote the initial edition, rather than simply serving as Mary's editor and primary supporter; many who believe this feel that it was impossible for a young woman of the time to craft a tale of dread horror.

It certainly didn't help that the original edition was published without credit to the author, and Percy provided the preface. Mary's diaries and her original drafts contained

OPPOSITE: A late-nineteenth-century cover for *Frankenstein* shows the monster face-to-face with his creator, Victor Frankenstein.

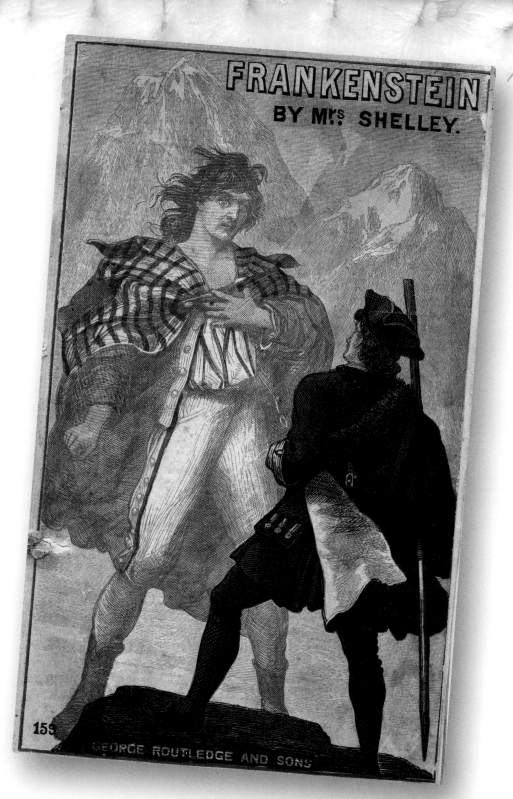

FRANKENSTEIN
BY M^{rs} SHELLEY.

159

GEORGE ROUTLEDGE AND SONS

in two journals that still exist today prompted further scrutiny, both clearing up the authorship and mudding the debate as well. Percy's handwriting is clear in the drafts, indicating he corrected some spellings and added text with language that is loftier and far more literary. Yet the overwhelming bulk of the text is clearly written in Mary's hand.

Mary's language may lack the grandiose poetry of her husband's, but many scholars agree that the common parlance is more befitting the story. There is also little question that the story includes experiences that resonated deeply with Mary and the aforementioned loss of her mother. Many of those skeptical of her authorship seem to base their arguments largely on a refusal to believe that a woman so young could write with such experience, and yet her diaries from the time leading up to the novel include numerous thoughts on the themes of mortality examined in the story. Whether Percy simply served as an editor or is deserving of more credit is largely dismissed by the greater academic community at this point, but it has plagued the narrative for years.

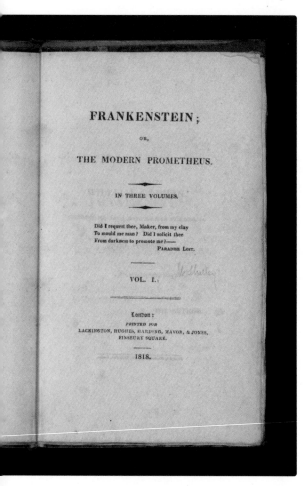

Mary and Percy's illicit relationship continued through the writing and editing of *Frankenstein*, until the pair wed on December 30, 1816. It was just weeks after Percy's wife, Harriet, committed suicide by throwing herself into the Serpentine River while pregnant with another man's child.

Percy shopped the *Frankenstein* manuscript around to publishers in London after he and Mary agreed that it should be published anonymously. Mary was looking to avoid having her family name, her age, and her gender affect the book's reception. She would continue

The title page of the first edition of *Frankenstein* features an epigraph from *Paradise Lost*. Shelley draws inspiration from Milton's work in her novel.

to work anonymously as she went on to publish additional novels, all with first editions credited only to "the author of *Frankenstein*." The book, which included Percy's preface, was published on New Year's Day in 1818 by Lackington, Hughes, Harding, Mavor, & Jones, a small publishing house in London. It was released in three volumes, which was tradition at the time, and had an initial print run of only five hundred copies.

Immediate reaction to the novel was mixed among critics, with both praise and a few insults heaped upon the work. Many initially credited the authorship to Percy or Lord Byron, writing their reviews with those authors in mind. In March 1818, Sir Walter Scott, convinced that *Frankenstein* sprung from Percy's pen, praised the novel in *Blackwood's Edinburgh Magazine*, saying, "Upon the whole, the work impresses us with a high idea of the author's original genius and happy power of expression." A month later, *Gentleman's Magazine* opened their review with praise: "The Tale is evidently the production of no ordinary Writer; and, though we are shocked at the idea of the event on which this fiction is founded, many parts of it are strikingly good, and the description of scenery is excellent."

Alternately, *Quarterly Review* largely dismissed the piece with a lengthy summary of the work capped off with commentary on the "tissue of horrible and disgusting absurdity this work presents." The writer goes on to savage the piece, in particular because it is dedicated to Mary's father, whose teachings were considered offensive by the journal's staff. Still, they found Percy's preface to be the one rational spot among "the dreams of insanity [that] are embodied in the strong and striking language of the insane . . . " They did wonder if the presumed male author of the work that followed was " . . . not as mad as his hero."

Mary Shelley would finally be credited for her writing with the second edition of the novel, published five years later. This version was released in two volumes and included over one hundred editorial alterations. As proposed by E. B. Murray in the article "Changes in the 1823 Edition of *Frankenstein*," it is possible that William Godwin made these edits, rather than Mary herself, as she was in Italy at the time of publication.

But it was the third edition of the novel, 0released on Halloween in 1831, that boasted Mary's most substantial revisions. This edition was contained in a single book, rather than split among volumes like its predecessors. She reordered the chapters, and the publisher included illustrations by William Chevalier. This edition also carried the introduction by Mary Shelley that detailed the contest that took place in Villa Diodati, adding that memorable anecdote to the already growing legend of *Frankenstein*.

For many years, academics considered the 1831 edition the preferred text for study. Revised over a dozen years after the initial printing, this edition shows how Mary had grown as a writer and was able to look back on her younger work with more mature eyes. But more recently, those teaching *Frankenstein* prefer to use the original, unadulterated text, written before Mary had reached maturity and without the years of revisions. Although Mary claimed in her introduction to the third edition that the changes to the text "were principally those of style," in truth, there were some considerable rewrites, though the overall story stayed the same.

LITERATURE THAT STARTED THE LEGEND

The original *Frankenstein* is a standout piece of literature that has been studied from many different angles. Even at the time, it was a prime example of Romantic literature, deeply rooted in the voice of the author, with a narrative devoted to emotion over reason. And, though it grew out of a ghost-story challenge and had a considerable impact on gothic horror, perhaps *Frankenstein*'s most important contribution is that it was one of the earliest works of science fiction. The science of the process by which Victor Frankenstein creates life is largely glossed over in the story, but countless articles, papers, and books have been written about the bioethics of the experiment. The book's prime legacy, in fact, is that it is seen as a cautionary tale on science run amuck. Its history is also explored in women's studies, with lessons moving beyond the female characters in the story and into the life and work of the author herself.

This is the literary legacy of *Frankenstein; or, The Modern Prometheus.* The life that Mary Shelley's creation has taken on has gone far beyond books. It has impacted society in ways the author never could have dreamed. And yet, some of that impact was felt in her lifetime. With only a relatively small number of copies in print, *Frankenstein*'s popularity first grew through word of mouth, infecting society as a concept as much as it did as a literary work. Shelley bore witness as her work stepped beyond the printed page.

THE MONSTER LEAPS OFF THE PAGE

Frankenstein's global success was born in the pages of Mary Shelley's manuscript, but he started to evolve in pop culture, outside of that initial five-hundred-copy print run. It began a few years after publication with the first stage adaptations of the story.

Much like book-to-film adaptations today, many of the theatergoing public in nineteenth-century England was first exposed to the Frankenstein story through plays based on the material. And, also like today's movies, the scripts for these stage plays often diverged wildly from the original text.

Presumption; or, The Fate of Frankenstein by Richard Brinsley Peake was the first recorded adaptation of Shelley's work. The play premiered in July 1823 at the English Opera House and ran for thirty-seven performances over the summer season. Its success is said to have prompted the printing of the second edition, which came out that same year. Because the adaptation was produced at an "illegitimate" theater in London—that is, any stage that was not the theaters Royal Drury Lane and Covent Garden—it could not be a straight performance of spoken drama or comedy. *Presumption* (later changed to *Frankenstein; or, The Danger of Presumption*) was billed as a romance, with musical entertainment and other spectacles mixed in. But while several of the characters perform musical numbers, the creature does not sing. That would come in future productions—most notably well over a century later in Mel Brooks's uproarious comedy *Young Frankenstein.*

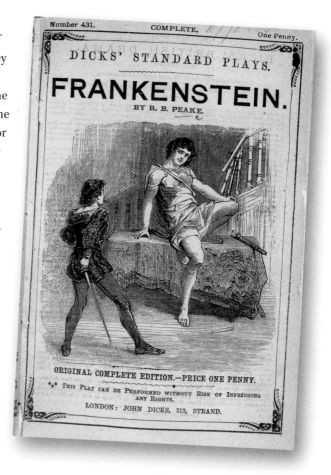

As a romance, *Presumption* includes multiple pairings. The central relationship of the book—Victor and Elizabeth's—is altered, turning them into siblings with other partners. Shelley's story is truncated, with large swaths of the original narrative left out, and the play concludes with the creature's spectacular—and special effects–laden—demise. This differs dramatically from the original tale in which the monster goes on to live out its life, presumably in solitude. Peake also gave Frankenstein a servant named Fritz, who assisted in the experiment and acted as a sounding board for

ABOVE: The playbill cover for *Presumption; or, The Fate of Frankenstein.* Brinsley Peake's 1823 stage play was the first recorded adaptation of Shelley's original novel.

MR Q. SMITH AS THE MONSTER.

in

FRANKENSTEIN.

London Pub.d by J. Duncombe, 19 Little Queen Street, Holborn.

Victor, allowing the audience to hear his plans. The addition of Fritz would pave the way for the more familiar Igor character in what would become the Frankenstein legend, and inspire a similarly named character in the 1931 film produced by Universal Studios. Fritz is also the person to whom Frankenstein is speaking when he utters the line that would later be slightly altered and become famous on its own: as Frankenstein brings the creature to life, he proclaims, "It lives!"

Shelley and her family attended an early production of the play. She was not a fan of the alterations to the story, but she did admit in a letter to a friend that she was impressed by the actor who portrayed the monster. In that same letter, she also appreciates that the production had written the creature's name in the cast list solely as a series of dashes and that "this nameless mode of naming the un[n]ameable is rather good." Shelley's opinion aside, the play was a smash and moved to the New Covent Garden in 1824. Its success also inspired Peake to create a burlesque version of his work, *Another Piece of Presumption*, only three months after the opening of his original play.

Frankenstein! or, The Demon of Switzerland, a musical melodrama by H. M. Milner, opened weeks after the premiere of *Presumption*. Its version of Victor Frankenstein is not a student obsessed with creating life; he is an accomplished scientist, paving the way for the mad doctor portrayal for centuries to come.

No matter the deviations from Shelley's work, the subject matter proved quite popular, and several additional versions of *Frankenstein* appeared on London's stages. Some were more straightforward, whereas others continued the tradition of the illegitimate theater, with titles like *Frankenstitch*, *Frank-in-Steam*, and *Frank-n-Stein, or the Modern Promise to Pay*.

The monster first began to be confused with its creator during this time. Audiences referred to both characters as Frankenstein. The mix-up persisted as the plays moved beyond the shores of England, with productions taking place in all the major theater cities of the world.

But it was a medium that didn't exist when Mary Shelley wrote her tale that would truly turn Frankenstein the *monster* into a household name 113 years after the character first appeared in print.

OPPOSITE: A playbill for an 1826 stage adaptation titled *Frankenstein; or, The Man and the Monster!*

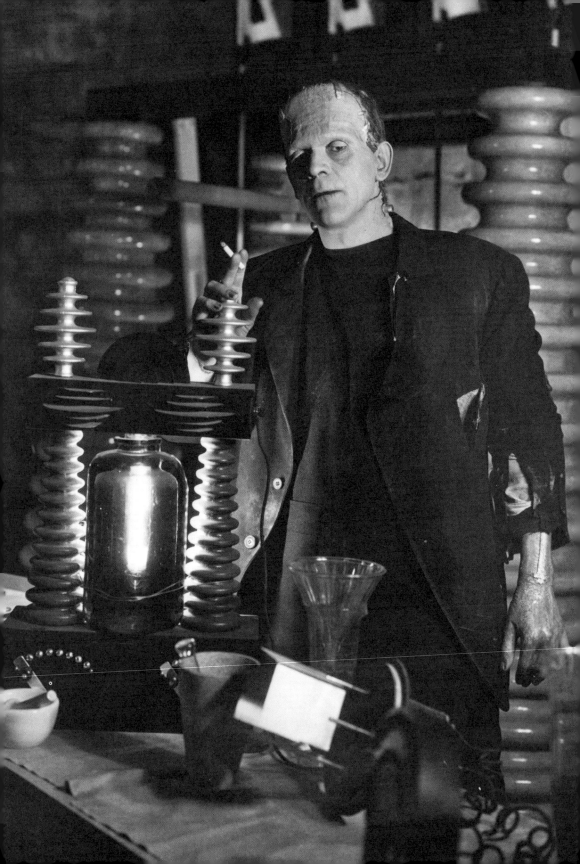

THE MONSTER EVOLVES

The art of storytelling has existed since the dawn of humanity. The archetypal cavepeople gathered around the fire to share tales of the day's hunt and memorialize them in pictographs on cave walls. In ancient Greece, storytelling evolved into theater and stage productions. The invention of the printing press irrevocably changed the art form, placing stories into the hands of any willing audience member. Stories eventually ended up on walls again, like those ancient cave paintings, but now projected through newly developed technology like the magic lantern, phenakistoscope, zoetrope, and praxinoscope. These inventions ultimately gave way to the one creation that would have as much of an impact on storytelling as when Thespis stepped out of the chorus in ancient Greece to become the first actor.

The device that became the motion-picture camera was first patented in 1876. Finally, a piece of technology could record images in rapid succession, rather than taking the time required to re-create still

OPPOSITE: Frankenstein's monster (Boris Karloff) inspects the laboratory where he was created, in a scene from *Frankenstein* (1931).

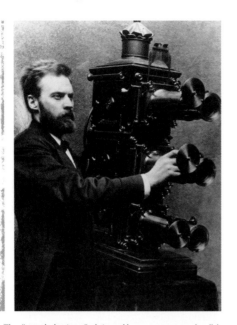

The "magic lantern" pictured here was an early slide projector. A skilled projectionist could operate the slides quickly to make them appear to move.

pictures. Soon, other cameras were being developed, along with the technology to view these newly recorded films. William Dickson, an employee of the Edison Company in America, was the first to combine the abilities to record and reproduce moving images within a single device, known as the kinetograph. To view the films, an individual would step up to the kinetoscope and peep through a hole in the wooden box, while mechanisms inside ran the images. It inspired the Lumière brothers in France to develop a machine that could project those images onto a screen, allowing for an audience larger than one. Other projectors followed, with the Edison Company purchasing similar technology and becoming the first commercial film company in the United States.

The Edison Film Company was also the first to bring Mary Shelley's monster to the screen. But it was their competitor, the Independent Motion Pictures Company—soon to become Universal Pictures—that had the largest impact on the mythology of the monster since Mary Shelley's words were first put into print.

A SILENT SHOWING

Frankenstein, the man and the monster, were already interchangeable by the turn of the twentieth century. The concept of a misguided scientific creation growing beyond the control of its maker had become part of the public consciousness. Even people who had never read Shelley's work or seen one of the plays based on her novel were familiar with the term and the concept. But that was nothing compared to how the mythology was about to grow beyond even Shelley's original intention in the second century of the daemon's life.

Frankenstein; or, The Modern Prometheus was quite popular at the end of the nineteenth century, as were the plays based upon the story. But its primary audience was still limited to readers and theatergoers. The advent of movies would change that.

Entertainment for the masses would expose everyday people to works of literature and history, opening eyes to stories they only may have previously heard of.

Some movies took great liberties with the source material. This was the case with the first film to bring Frankenstein to the screen—and it proudly proclaimed as much, with the opening title card calling it "A liberal adaptation from Mrs. Shelley's famous story."

It was 1910, not quite a century since the book was first published. Edison Studios rapidly cranked out movies and would produce over one thousand films in their twenty-five-year existence. While they made over fifty full-length features in this time, most of these movies were short subjects, often roughly fifteen minutes in length. The first material largely consisted of recordings of daily life. These predecessors to documentaries and reality shows were called "actualities," a term coined by the Lumière brothers to describe their own films, mostly recorded outdoors on location. The earliest Edison films were typically shot in a small studio in West Orange, New Jersey, and featured acrobats, boxers, dancing girls, and vaudeville performers.

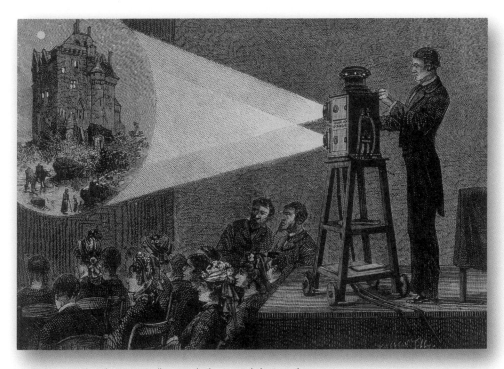

An 1881 engraving shows an audience enjoying a magic lantern show.

Actualities quickly gave way to films with stories, thanks to competition in Europe for a burgeoning fictional film market. And Edison Studios quickly moved into fiction, producing several notable films, such as *The Great Train Robbery* in 1903 and an adaptation of Lewis Carroll's *Alice's Adventures in Wonderland* in 1910. A week after *Wonderland* premiered in theaters, Edison came out with another work based on a famous literary treasure. March 18, 1910, saw the first film release of a *Frankenstein* movie. It would not be the last.

J. Searle Dawley wrote and directed the fifteen-minute silent film, which he shot in under a week at the new Edison Studios stage in New York before quickly moving on to the next production. It wasn't until decades after his death in 1949 that Dawley would be celebrated for his place in history as the director of the first film adaptation of Mary Shelley's work. In his lifetime, he was just a simple filmmaker who directed 149 movies in a career that lasted twenty years. The uncredited cast of his movie included prolific screen actors Augustus Phillips as Victor Frankenstein, Mary Fuller as his fiancée, and Broadway star Charles Ogle as the monster. This "liberal adaptation" intentionally toned down the horror elements of the original story, according to a selling point listed in the catalog provided to theater owners: "Wherever, therefore, the film differs from the original story it is purely with the idea of eliminating what would be repulsive to a moving picture audience."

Condensing Shelley's work into a fifteen-minute film also meant there would be wholesale cuts beyond anything that would have offended the sensibilities of the audience. Gone are the murders and the chase, and all evidence of the monster growing and learning to become a philosopher in its own right. The condensed story follows Victor as he goes off to school and, two years later, creates life. He does not do this in secret though, as he had in the book. He proudly proclaims his discovery to his girlfriend, writing that his success means that they can now wed.

Victor is almost immediately horrified by his grotesque creation, and the monster is equally disgusted with itself upon seeing its reflection in a mirror. When the monster witnesses the love between Victor and his new wife, it fades away into nothingness, knowing that it can never find that type of companionship. "The creation of an evil mind is overcome by love and disappears," the title card explains. The monster's reflection briefly remains in the mirror, allowing Victor to witness the strange event before that reflection morphs into Victor himself.

The brief film perfectly captures the dual nature of Victor and his creation, with the scientist literally seeing the monster reflected in himself. But due to the constraints of time and audience perspective, it leaves out nearly everything else. Most notably,

the science of creation is replaced by something more like a witch's brew, as biology and anatomy give way to chemistry. Victor no longer builds his patchwork creation from body parts found in morgues and cemeteries. Instead, he creates an elixir of life that, when poured into a cauldron, gives rise to a body formed out of nothingness. This impressive special effect was created easily enough by burning a model of the monster and then simply running the film in reverse.

As one of dozens of films released that week—with as many more released in the week that followed—this first movie adaptation of *Frankenstein* did not have a historic effect on audiences. Looking back, it's difficult to say what the response to the movie was. Film reviews and criticism were not yet established fields, so very little commentary on the movie was produced during its brief lifetime. For many years, the only real evidence of its existence was its inclusion in the Edison Film Company's catalog for March 15, 1910. The short quickly faded away into obscurity.

Until 1980, when *Box Office* magazine published a list of the ten most important films lost to history. Eldest among these was Dawley's *Frankenstein*. Alois Dettlaff, a film collector, read the article and realized that a purchase he'd made almost three decades earlier just happened to be that missing masterpiece. The 35mm film was in poor condition, but Dettlaff had it restored and started showing it at local theaters on Halloween. He eventually released the short on DVD in a double billing with the 1922 film *Nosferatu*, marketing the collection as a back-to-back commemorative edition of "Cinema's First Monsters." *Frankenstein* was advertised with its approximately fourteen-minute running time, original tints, and music score.

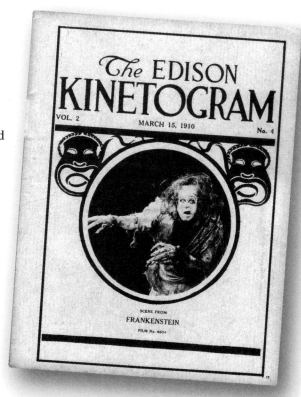

The cover of the 1910 *Edison Kinetogram* film catalog shows an image from *Frankenstein*, the first-ever film adaptation of Mary Shelley's original.

CARL LAEMMLE *presents*

FRANKENSTEIN

THE MAN WHO MADE A MONSTER

with

**COLIN CLIVE, MAE CLARKE,
JOHN BOLES, BORIS KARLOFF,**
DWIGHT FRYE, EDW. VAN SLOAN & FREDERIC KERR

Based upon the
Mary Wollstonecroft Shelley Story

Adapted by John L. Balderston
from the play by Peggy Webling

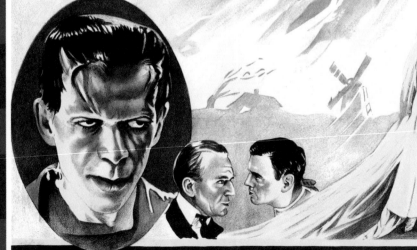

DIRECTED BY
JAMES WHALE

A UNIVERSAL PICTURE

PRODUCED BY
CARL LAEMMLE, JR.

Today, the film has entered the public domain, and you can even find it for free on YouTube.

Two other silent films came out in the decade that followed, though they would prove to be mere blips on the radar of *Frankenstein*'s legacy. *Life Without Soul* was released in 1915 and though it has no ties to the name Frankenstein, the story of a man who creates a monster that he chases across Europe after it murders his sister has clear parallels to the tale. A more direct adaptation, with at least a scene directly influenced by the book, was released in 1920 with the Italian film *Il Mostro di Frankenstein*. Both movies have been lost to time, a trend that would soon end with the next notable entry in the mythology.

FRANKENSTEIN IS UNIVERSAL

Anyone familiar with the Frankenstein monster knows that 1931 was a watershed year in the creature's history. That was the year when Universal Studios released James Whale's

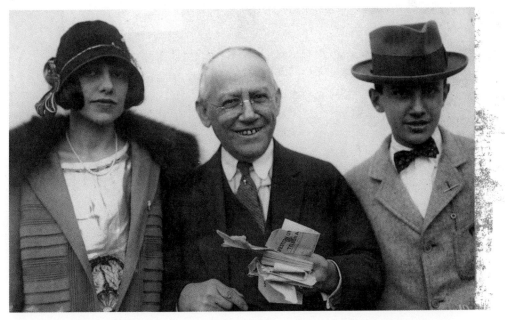

ABOVE: Carl Laemmle—pictured here with his children, Rosabelle and Carl Jr.—was the head of Universal Pictures. When he handed the reins to his son, Carl Jr. made the horror genre a huge success for the company.

OPPOSITE: The Universal Pictures version of *Frankenstein* would vault the monster into the public consciousness. Here, Boris Karloff is featured in movie art for the 1931 film.

Frankenstein (Basil Rathbone) proves the legitimacy of his father's scientific work with the help of Ygor (Bel Lugosi) in *Son of Frankenstein* (1939).

Frankenstein, starring the relatively unknown journeyman actor Boris Karloff. The film—and Karloff's portrayal—launched an already popular character into the stratosphere of pop culture stardom, and added more to the monster's legacy than almost any other piece of fiction since Shelley's novel was first released. It cemented many of the changes to the mythology that had been introduced in earlier plays and created a new legend. It also took a significant step in blurring the lines between Frankenstein the man and Frankenstein the monster. The film spawned multiple sequels that, among other things, finally gave the monster a bride.

But, most important, the Universal film gave Shelley's daemon something it had been searching for since its initial publication: Frankenstein finally had friends.

The story of *Frankenstein* has always been about a lone creature exiled from society, seeking companionship. That didn't change in Whale's version of the tale, despite the many liberties Universal took with the subject matter. But outside of the story, it was another matter entirely. Frankenstein the monster in that 1931 film was one of the earliest stars in what was about to be a blockbuster horror-movie franchise for Universal Pictures. The Frankenstein monster would soon be forever linked to the Wolf Man, the Mummy, the Invisible Man, and, of course, Dracula.

To say that Frankenstein would not exist without Dracula would be a dramatic overstatement, but the vampire certainly helped Frankenstein's impact. Carl Laemmle, Universal's founder, was not a fan of horror, but there was no question that scary movies were already attracting fans of the talkies by the early thirties. His son, Carl Jr., however, was most certainly a fan of both the genre and its impact. When Carl Jr. was made head

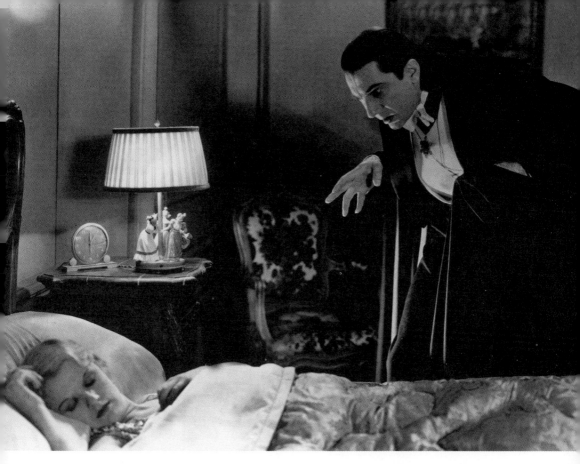

In this scene from *Dracula*, Dracula (Bela Lugosi) is set to pounce on Mina Seward (Helen Chandler).

of production at Universal Studios—a gift for his twenty-first birthday in 1928—the younger Laemmle eventually turned his father around on the subject. Their entry into horror films occurred with the release of the Tod Browning–directed *Dracula*, starring Bela Lugosi, on February 12, 1931.

Like *Frankenstein* would be, *Dracula* was inspired by a stage play that was loosely based on Bram Stoker's original book. The film also shares some commonalities with *Nosferatu*, a 1922 German impressionist film whose producers did not bother to get the film rights from the author's estate. Stoker's widow sued that production, resulting in the destruction of almost all prints of *Nosferatu*. (A surviving print of the film would surface years later and be paired with the 1910 *Frankenstein* in Dettlaff's DVD release.) The 1931 Universal Studios version of *Dracula* is an authorized adaptation, but it still takes many liberties with the story. That didn't matter to audiences though. The movie quickly became a massive success for the studio. It was the biggest film release that year, raking in over $700,000 and launching Lugosi into superstardom.

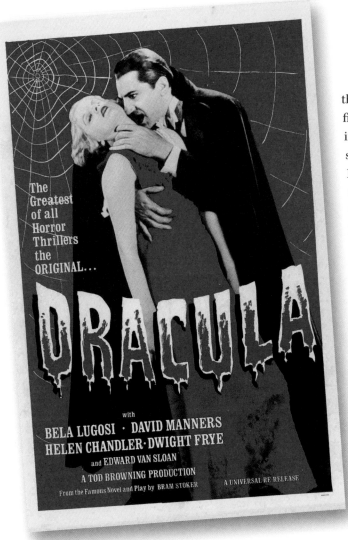

The Greatest of all Horror Thrillers the ORIGINAL...

DRACULA

with
**BELA LUGOSI · DAVID MANNERS
HELEN CHANDLER· DWIGHT FRYE**
and EDWARD VAN SLOAN
A TOD BROWNING PRODUCTION
From the Famous Novel and Play by BRAM STOKER A UNIVERSAL RE RELEASE

A movie poster promotes *Dracula* (1931), starring Bela Lugosi.

Dracula was a savior for the studio, which had had a financially disastrous year in 1930. Universal was still struggling to make its name in Hollywood, and the Depression certainly hadn't helped. Due to the financial issues, the Laemmles had to shut down production at the studio for six weeks in March and April, until the influx from Dracula's box office helped turn things around. By the end of August that year, *Frankenstein* was in production.

MAKING THE MONSTER ANEW

The original concept for this adaptation of Mary Shelley's work was taken from a play written by British playwright Peggy Webling. She was working for Hamilton Deane, an actor-producer who had already had great success with the *Dracula* stage play that would later become the film.

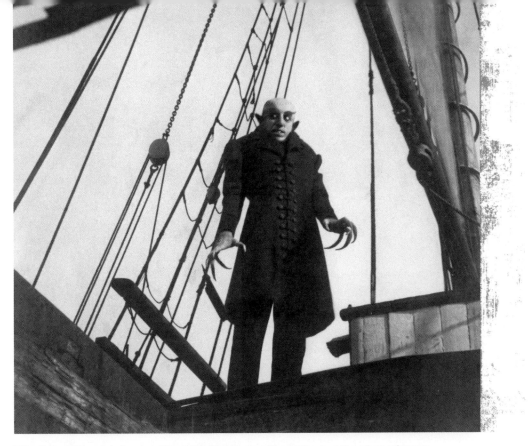

This off-brand Dracula is the star of the 1922 silent German film *Nosferatu: A Symphony of Horror*, directed by F. W. Murnau.

Hamilton Deane's production of *Frankenstein: An Adventure in the Macabre* first premiered in December 1927, and it toured for two years before opening to tepid reviews in London in 1930. John L. Balderston was then hired to adapt the play for the American stage, as he had done with *Dracula*. That play was never produced, but Universal bought the film rights to the script.

Webling's script notably changes the name of the main character by introducing *Henry* Frankenstein as the doctor and giving his friend the name Victor. The film would do the same, along with setting the action in the town of Goldstadt, a holdover idea from Balderston's adaptation. But the play's focus on the duality of the nature between the scientist and his creation would be its greatest impact on the Frankenstein legend. Webling's script presents both Frankenstein and his monster as two sides of the same character, with the actors even dressing alike onstage. But just two lines of dialogue cemented what had already been unofficially accepted about the monster for decades: "I call him by my own name," says Henry Frankenstein. "He is Frankenstein."

Universal Studios executives hired Robert Florey to script and direct their version of *Frankenstein*, but the film languished until James Whale took an interest. Whale had recently experienced great success with his play turned movie: *Journey's End*. It was considered one of the top films of 1930, and Whale found himself in high demand in Hollywood. Universal executives enticed him onto the studio payroll, giving him his pick of projects. Not wanting to be pigeonholed as a war director in light of the success of *Journey's End*, Whale jumped at the opportunity to try his hand at horror.

The studio initially wanted Bela Lugosi for the role of Frankenstein's monster, hoping to ride the actor's huge success in playing Dracula. Lugosi, however, was not charmed by the character. He'd been more interested in the titular role of Henry Frankenstein—and the four hours of makeup he had to endure for a twenty-minute screen test as the monster certainly didn't help. Lugosi refused to do any more tests. But Whale's changes would put the final nail in the proverbial coffin for the actor: Whale's version of the monster had no dialogue beyond grunts and groans. Lugosi reportedly

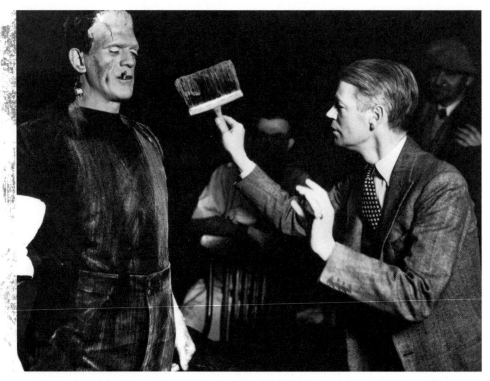

Director James Whale with Boris Karloff, as he smokes a cigarette between takes of *Frankenstein* (1931).

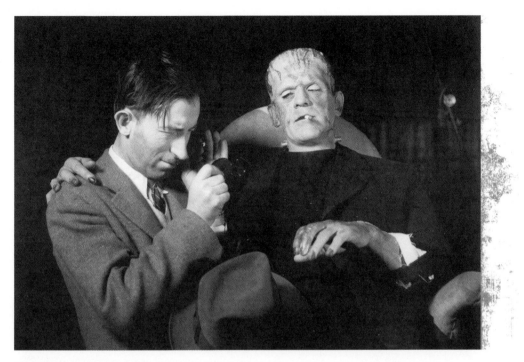

Director James Whale consults with Boris Karloff, playing Frankenstein's monster, behind the scenes of filming *Frankenstein* (1931).

flew into a rage when he found out, and turned down the film. He would go on to star in *Murders in the Rue Morgue* for *Frankenstein*'s original writer-director Robert Florey, leaving the monster to be Karloff's breakout role. The decision would lead to a rivalry between the actors that would last for years.

Frankenstein would make Boris Karloff—born William Henry Pratt—an overnight success, after twenty years spent toiling away at theater work and smaller parts in films. His relationship with the monster famously began while he was having lunch in the Universal commissary, during the filming of the political thriller *Graft* (1931). In what has become a story of Hollywood legend—true or not—Whale is said to have caught sight of the actor there and beckoned him to the director's table. Karloff was smart enough to know that when one of the most important directors on the lot demands an audience, you go immediately. Whale began with what the actor thought was a compliment, stating that Karloff's face had "startling possibilities." Karloff only deflated slightly when Whale added that he wanted to test him for the part of the monster in *Frankenstein*. Whale would go on

to say that the meeting had inspired him for the look of the monster, and he immediately drew up some sketches of the creature with Karloff's features.

Karloff continued work on *Graft*, but he would meet with makeup artist Jack Pierce after filming was done for the day. The two experimented with makeup treatments, refusing to show their results until they were both happy with the work, in spite of pressure from the studio to reveal Pierce's design. When they finally did unveil the look of the monster, it was nothing like Mary Shelley's description, which was "His yellow skin scarcely covered the work of muscles and arteries beneath; his hair was of a lustrous black, and flowing; his teeth of a pearly whiteness . . ." Instead, the look that Pierce created—the creature's flattop head beneath dark, matted hair, with a high forehead, sunken cheeks, and neck bolts—would become the appearance of the Frankenstein monster for a century to come.

Whether the new look of the monster came from Whale's sketches or entirely from Pierce's imagination is up for debate. Either way, Pierce did not rely exclusively on his own imagination to craft the appearance. As Pierce explained to the *New York Times* in 1939, real science factored in:

> *I discovered there are six ways a surgeon can cut the skull, and I figured Dr. Frankenstein, who was not a practicing surgeon, would take the easiest. That is, he would cut the top of the skull straight across like a pot lid, hinge it, pop the brain in, and clamp it tight. That's the reason I decided to make the Monster's head square and flat like a box and dig that scar across his forehead and have two metal clamps hold it together.*

Once the monster's look was approved, filming began. For Karloff, it was torturous, aggravated by the sixty-five-pound (29 kg) costume that would pad his already tall frame to an impressive seven-foot, six-inch height. The monster costume also established another element of the Frankenstein mythos: the creature's overly long arms and legs peeking out from clothing that barely fit. Karloff's feet were encased in approximately thirty-pound (14 kg) weighted boots. The long days of filming in the heavy-duty costume exacerbated his back problems and ultimately sent him to the hospital years later for spinal fusion surgery. The pain might have been worth it

OPPOSITE: As influential as Karloff's portrayal of the monster was makeup artist Jack Pierce's artistic vision. Born Janus Piccoulas in 1889, the Greek makeup artist applied makeup for hours to achieve what would become the iconic green hue and flattop head of the monster.

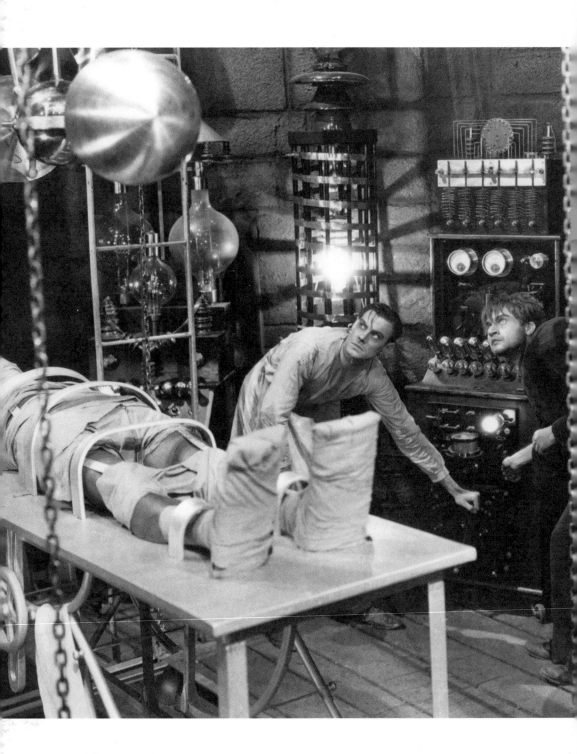

though. Karloff would forever be associated with the character, and his career would never be the same.

The monster in Webling's *Frankenstein: An Adventure in the Macabre* was written—and performed—to evoke empathy from the audience. This was another theme that Whale and Karloff brought to the film, though it's doubtful that studio executives were looking for such a tender performance from their monster. But the decision was sound; the film produced a creature that was equally sympathetic and horrific.

The creature's appearance wasn't the only liberty that the production took with the original source material. The film would introduce or popularize several other additions to the Frankenstein mythos.

In the 1931 film, Dr. Henry Frankenstein does not toil away in secret at his university, within "a solitary chamber, or rather cell, at the top of the house, and separated from all the other apartments by a gallery and a staircase," as Shelley imagined it. He works in a stone tower, with a cavernous interior that likely inspired the future castles that would be associated with the "mad scientist." And this Frankenstein isn't yet a mad scientist, per se. He is impassioned, certainly, but the madness would come in the sequel with another character, and in future versions of the story from other film studios.

In the birth of the monster, electricity is alluded to in the novel, but the process by which

Dr. Henry Frankenstein (Colin Clive) and his assistant, Fritz (Dwight Frye), flip the switch that will reanimate the monster they've created, in *Frankenstein* (1931). Dr. Frankenstein will utter the now-famous words, "It's alive! It's alive!"

Frankenstein goes about creating life is largely left to the reader's imagination. Playwrights over the decades had hooked into this concept, but it is Whale's use of lightning and spectacular visuals created by special-effects artist Kenneth Strickfaden that would change the Frankenstein story. Similarly, the doctor's repeated, excited declaration "It's alive!" was not only woven into the monster's legacy but became a popular phrase on its own, exclaimed in movies, on television, and in everyday life whenever a strange life form or inanimate object suddenly shows some signs of movement.

The monster that comes to life in that scene possesses the abnormal brain of a murderer, thanks to another deviation from the original story. That brain—obtained by Frankenstein's assistant, Fritz—would become the explanation for the creature's actions, muddying the motivations of the pitied being. No such reason existed in Mary Shelley's tale for the monster's attacks. Nor did the assistant exist. Fritz was a concept from the 1823 play *Presumption; or, The Fate of Frankenstein*. The hunchbacked servant would become the monster's first victim and go on to inspire the character of Igor, another associate in the mythology that did not exist in the original text.

Like it is in the novel, this creature is attacked for its monstrous appearance. Fritz torments the confused wretch from its beginning, finding pleasure in the fact that the monster fears fire—something that it originally found fascinating in Mary Shelley's book. This torment drives the monster to commit its first murder, killing Fritz to protect itself. The fire imagery would later give rise to the mob of torch-wielding villagers that also became a staple in stories of this nature. This may not have been the first time torch-wielding villagers appeared in a horror story, but it has become one of the most famous associations of the trope.

Frankenstein's monster isn't just a murderous animal. Certainly its first two kills in the movie can be attributed to self-defense. Karloff puts great depth and pathos into a role that has no dialogue. Again, unlike Shelley's creation, the creature never learns to speak in its initial film outing. It does, however, escape its laboratory prison to go out and learn about the world. The most tragic lesson comes when it meets a young girl, who becomes its third victim through an innocent accident.

Little Maria does not shy away from the creature's horrific features. In fact, she asks it to join her in making small flower boats, dropping them in the lake and watching them float. The Frankenstein monster is so moved by this simple act of beauty that it becomes distraught when they run out of flowers. It picks up little Maria and drops her into the lake instead, hoping to re-create that serenity with the child. But rather than float, Maria sinks to the bottom of the lake, leaving the creature in despair.

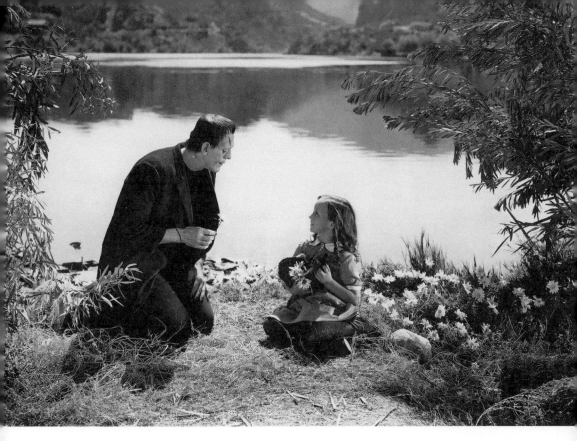

In this still from the 1931 *Frankenstein*, the monster makes a friend.

Censors made the studio cut down the tragic scene, however. When the movie was released, the scene ended with the monster reaching for Maria before the camera cut away. Later, the dead girl's father carries her body into town, and the villagers become furious about her death. Gone was the monster's reaction to the horror—and with it, something that would have audiences empathize with the creature. The lost scene would be put back into the film when the clip was rediscovered in the eighties, but the damage was done. To further mollify concerns that the film was too violent, a scene was added at the end, showing that Dr. Frankenstein survived the events of the film. Of course, the monster would later be revealed to have survived as well, because the movie was about to become one of the most popular films in history.

FRANKENSTEIN'S FILM DEBUT

The studio held a preview of *Frankenstein* at the Granada Theatre in Santa Barbara, California, on October 29, 1931, less than a month before the official opening of the film. Audiences were said to have been so horrified by the movie that they called the

theater owner in the middle of the night to complain about their nightmares. Whether this is true or a Hollywood legend is difficult to say, but it was clear that the film had a strong effect on viewers. Studio executives initially worried that they'd created too much of a monster, that audiences would be scared away. But they soon realized that they needed to encourage and advertise the terror. The marketing department created an ad campaign that played into the fervor. Ads declared, "No thriller ever made can touch it!" and "To have seen *Frankenstein* is to wear a badge of courage!" One cautioned: "If you have a weak heart and cannot stand intense excitement or even shock, we advise you NOT to see this production. If, on the contrary, you like an unusual thrill, you will find it in *Frankenstein*."

When the film premiered in New York on December 4, *Frankenstein* drew crowds on a rainy opening night and became Broadway's biggest movie hit that year. Extra showings were scheduled, with the Mayfair Theatre selling tickets to screenings as late as 2:00 a.m. There, *Frankenstein*'s first week set a new house record of $53,800 (a dramatic increase from the previous week's film, at $19,000). A month later in Los Angeles, lines began forming early for the 10:00 a.m. showing on opening day, and the queues remained until midnight. The theater even dropped the usual shorts and newsreels from their schedule that day to fit in more screenings.

Word of mouth continued to aid in the promotion of the film, as did the censorship it encountered. Some municipalities refused to show the movie. Other state censors demanded cuts so deep that they muddled the story to a confusing degree. Theatergoers in Detroit and other locations reportedly fainted during screenings, though rumors persist that Universal Studios hired these particular audience members to help build buzz. The difference between marketing and true audience reactions mattered little, however. *Frankenstein* went on to become one of the top films of the year, ushering in a series for Universal that would endure for over a decade.

THE SPAWN OF FRANKENSTEIN

With the blockbuster success of *Frankenstein*, a sequel was the only logical course of action. Director James Whale, however, was not interested in coming back to his monster. Like before, with war movies, he was concerned about being pegged to horror, especially after teaming up with Karloff again for *The Old Dark House* in 1932, and then going on to direct another formidable entry in his résumé in *The Invisible Man* with Claude Rains in 1933. Whale followed up these movies in 1934 with the comedy *By Candlelight* and the drama *One More River*. The latter film was critically acclaimed but failed to attract the kind of audience the studio expected from their star director. Its

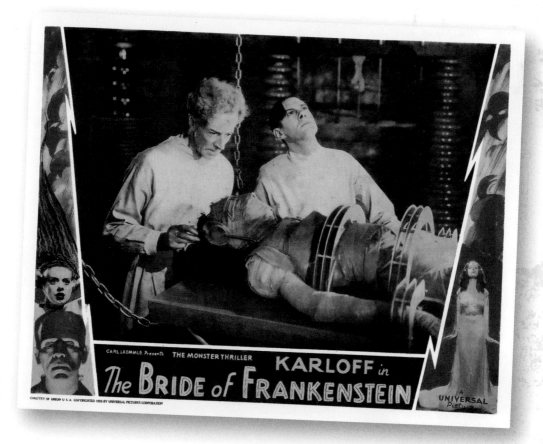

A movie poster for *The Bride of Frankenstein* (1935), the sequel to the 1931 hit *Frankenstein*.

reception may have played into the studio's push for Whale to return to the monster that had made them famous. But they did sweeten the deal with a hefty director's fee.

Karloff, of course, returned as that monster. But now the actor enjoyed a much higher ranking in the film industry than he had just four years earlier when he was not even named in the opening credits of *Frankenstein*. Instead, there was a question mark in the cast list where his name should have appeared. The relatively unknown actor's identity was left a mystery until the closing credits. That changed with the film's sequel in 1935. *Frankenstein* had turned Boris Karloff into a *star*. Audiences came to see him as much as the monster. "Carl Laemmle presents KARLOFF in . . . *Bride of Frankenstein*" big, bold letters proclaimed before the title. At the height of the actor's popularity, the studio referred to him merely by his last name. His level of stardom rendered a full name unnecessary.

In *The Bride of Frankenstein*, it is "The Monster's Mate" who gets a question mark in both the opening and closing credits. But it's not a snub: Elsa Lanchester plays both the

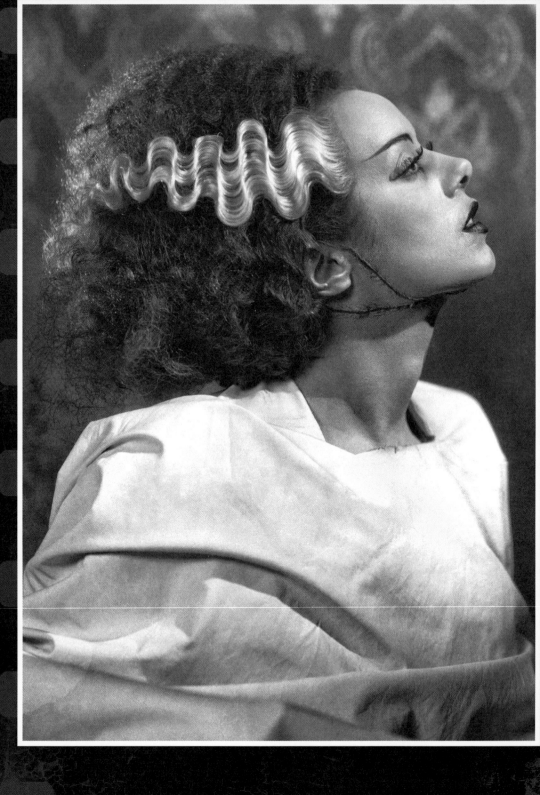

bride at the end of the film and Mary Wollstonecraft Shelley in the beginning, and she's credited for that.

The film opens in the past—1816 to be exact—taking great liberties with the events of the night that a bet between writers led to Shelley's masterpiece. In a dark foreboding castle, Mary Shelley sits with just Lord Byron and Percy Shelley, as the men lavish praise on her for her story. In this version of that night, she had already written her tale. They quickly recap the plot of the first film while clips bring the audience up to speed. (Technology was still decades away from allowing viewers to rewatch the first film at their leisure in their own homes before attending the sequel.) Mary then explains that *Frankenstein* wasn't her only story about the monster, and that there is more to the tale.

That part was true. There was more to the story. At the start of the film it is made clear that the script is "suggested by the original story written in 1816 by Mary Wollstonecraft Shelley." *The Bride of Frankenstein* does borrow heavily from the plot of the original novel, with the monster learning to speak and making a friend in a blind "hermit." In the novel, this occurs over a period of months, in which the monster watches the blind man and his family, while learning to read and write and growing quite intelligent. It comes to think of the family as friends, until everything goes horribly wrong when the creature attempts to reveal itself. Dramatically edited down in the film, the monster learns to speak only a few words and simple sentences, but the interaction tragically ends the same way: the monster is chased away.

Liberties continue to be taken in the screenplay. Most notably, Dr. Frankenstein never actually gives life to a companion in Shelley's story. In *The Bride of Frankenstein*, however, he is pressed into service when the monster and a truly mad scientist, Dr. Pretorius, kidnap Dr. Frankenstein's wife, Elizabeth, and force Henry to re-create life in a feminine form. The monster's journey is even more deeply felt in this story, tapping further into its "humanity" while it kills even more indiscriminately. The film ends with the ultimate tragic irony: the monster's "bride," who appears only at the very end of the film, reacts to the sight of him by screaming in unrelenting terror.

The Bride of Frankenstein is the film that completely demolishes the line between the creator and his creation. From this point on, Frankenstein is the monster. Sure, the cast list refers to the bride as "The Monster's Mate," but the title was much more direct; she is the bride *of* Frankenstein. While an argument can be made that the title could refer to the bride who was a creation of Frankenstein, what audiences took away was that she was Frankenstein's—the monster's—bride. It's made perfectly clear when

OPPOSITE: Actress Elsa Lanchester, playing the Bride, joined cast members from the 1931 movie.

Character actress Una O'Connor, playing Minnie, brought a large dose of humor to *The Bride of Frankenstein* (1935) to counterbalance the pathos of the story.

Dr. Pretorius declares the mate the "bride of Frankenstein," as wedding bells peal in the background toward the end of the film.

Like the previous movie, *The Bride of Frankenstein* was a grueling shoot. Makeup artist Jack Pierce slightly altered the look of the monster as a result of the fire it had survived, with new burn scars, singed hair revealing the sutures in its forehead, and dingier clothing. The costume was even heavier than the first and likely contributed to Karloff dislocating his hip while filming in the water beneath the demolished windmill.

Beyond the physical challenges with the role, Whale and Karloff emphasized the character's pathos, with the monster giving up its life at the end as a sort of penance for its sins. The creature takes the evil Dr. Pretorius and the bride along, too, as they all "belong dead." To offset the drama and the horror, Whale turned up the humor. Characters like Una O'Connor's Minnie bring broad comedy to the story. The end result is a film that was at times dramatic and moving while also good, campy fun.

The Bride of Frankenstein was an expensive film to produce, and it didn't quite match the success of its predecessor, leading to a brief moratorium on horror films at the studio. Whale would never direct an entry in the genre again, but it wasn't long before Universal got back into the business. Whale would forever be linked to Shelley's monster, even beyond his death by suicide in 1957. Decades later, his life would be memorialized in Christopher Bram's novel *Father of Frankenstein*, the fictionalized story of Whale's final days. That book inspired the movie *Gods and Monsters*, starring Sir Ian McKellen, Brendan Fraser, and Lynn Redgrave. It won the Academy Award for Best Adapted Screenplay, with both McKellen and Redgrave earning acting nominations for their performances. The movie's title was taken from Dr. Pretorius's toast in *The Bride of*

The Bride Enters

While Mary Shelley's Dr. Frankenstein goes through the motions of constructing a female companion for his monster, he never gives the creature life. That changed with James Whale's movie sequel. Initially, Whale's concept was that the bride would have been created from Elizabeth's body after the monster killed her to punish her husband, Henry, but the director was talked out of the dark idea. Instead, he returned to the concept from the novel, with Frankenstein collecting body parts as he did with his initial experiment. Jack Pierce crafted the look of the bride, allowing Elsa Lanchester's beauty to shine through the makeup, with strategically placed scars for effect. Whale has been credited with the most striking element of her look: the shocked black-and-white hair, with rows of waves sticking straight up from her head.

Much like her male counterpart, the bride and her unique appearance would continue to inspire in both horror and comedy. The sequel made her an ever-present part of the mythology, expanding the Frankenstein legend further beyond Shelley's work. She's appeared in countless representations over the decades. She was famously lampooned in *Young Frankenstein*, when Elizabeth, as played by Madeline Kahn, turns into the bride—complete with shocking hairdo— after a romantic liaison with the monster. The hairdo has been re-created with homages in everything from *The Rocky Horror Picture Show* to *The Munsters*.

The bride weaves in and out of Frankenstein's story from Whale's movie onward. Whale's initial concept for the origin of the bride was later used in *Mary Shelley's Frankenstein* (1994), in which the monster does kill Elizabeth, and Frankenstein brings her back to life. But her most prevalent outing was in the 1985 film *The Bride*, starring Jennifer Beals as the bride, Eva, and Sting as the misguided Baron Charles Frankenstein. This version takes a dramatically different turn, with Frankenstein creating a beautiful woman for the monster but growing obsessed with her in the process. The monster, Viktor (Clancy Brown), ultimately saves her from Frankenstein and the pair rides off to Venice together. The film was not financially or critically successful.

The 2026 Maggie Gyllenhaal-directed adaptation, *The Bride!*, starring Jessie Buckley, Christian Bale, Penélope Cruz, Peter Sarsgaard, and Annette Bening, introduces a new take on the titular character. Set in the 1930s, this interpretation gives her a new voice by making the story into a musical.

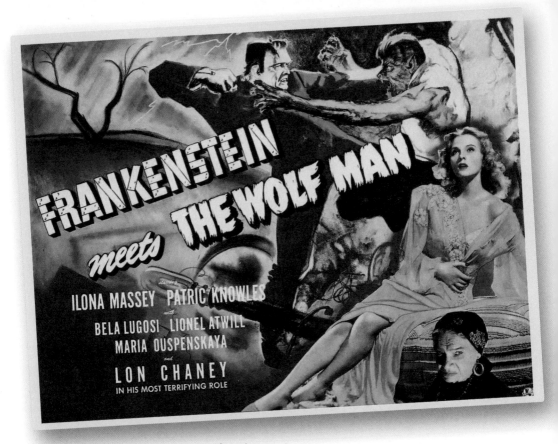

A movie poster for *Frankenstein Meets the Wolf Man* (1943), starring Lon Chaney Jr. and Bela Lugosi.

Frankenstein: "To a new world of gods and monsters. The creation of life is enthralling, distinctly enthralling, is it not?"

Boris Karloff would play the monster only one more time after *The Bride of Frankenstein*, but his association with the mythology didn't end there. Over the next decade, Universal produced four more horror films with Frankenstein in the title and different actors in the role: *Son of Frankenstein* (Karloff), *The Ghost of Frankenstein* (Lon Chaney Jr.), *Frankenstein Meets the Wolf Man* (Bela Lugosi), and *House of Frankenstein* (Glenn Strange). The monster had a final outing for Universal in 1948, when the character moved into comedy with the film *Abbott and Costello Meet Frankenstein*.

Karloff transitioned from the heavily weighted monster costume into the newly created role of Dr. Gustav Niemann for the sequel *House of Frankenstein*, but that was his last time appearing in the Universal *Frankenstein* series. He did go on to perform the role of Baron Victor von Frankenstein in *Frankenstein 1970*, a science-fiction

film distributed by Allied Artists in 1958. Karloff remained proud of his association with the character and the legacy of his work up until his death, preferring to focus on what he and Whale created together rather than what the creature later became. In spite of what the actor considered a weakening of the character, the Universal *Frankenstein* films remain standout entries in the creature's two-hundred-year legacy.

FRANKENSTEIN IN LIVING COLOR

Following Frankenstein's meeting with the comic duo Abbott and Costello in 1948, the scientist and his creature had a dry spell in film. That's not to say that both Frankensteins faded into obscurity—far from it—but the film legacy did noticeably drop back. That changed in 1957 when Hammer Films Productions picked up the torch, with the first of seven new Frankenstein

Boris Karloff comes face-to-face with serious laughs in *Abbott and Costello Meet the Killer, Boris Karloff* (1949), starring comic duo Bud Abbott and Lou Costello. Just a year earlier, Abbott and Costello met Frankenstein, or Karloff, in his full monster makeup.

movies produced over the next sixteen years and ushering the monster into the era of vivid color.

The British production company was originally formed in 1934, around the time the final script for *The Bride of Frankenstein* was being completed. The brainchild of William Hinds, the company took its moniker from his stage name, Will Hammer, which in turn had been adapted from the Hammersmith neighborhood in London where he grew up. The company struggled for years, going out of business and then reforming, before eventually developing a reputation for film noir projects. Hammer Films experienced

a slow period in the mid-1950s, when their film output was cut to mostly shorts. Their fortunes changed with *The Quartermass Xperiment*, a science-fiction–horror movie that opened in the United States with the title *The Creeping Unknown*.

The gore of *The Creeping Unknown* earned it the newly developed X rating, which forbade anyone under the age of sixteen from seeing the movie. Rather than edit some scenes out to change the rating and bring the film to a wider audience, Hammer Films embraced the X as a badge of honor. They even promoted it by altering the original spelling of the title to "*Xperiment.*" It was a sound decision. The movie was a hit in both England and the United States, inspiring sequels and a shift in the development slate for Hammer Films. Suddenly horror was hot again, and the company was committed to pursuing it—beginning with a particular classic character with an established reputation in film. Frankenstein was about to rise again. It would just take a little bit of work.

The script that Hammer Films started with had some significant problems, particularly its similarity to Universal's *Son of Frankenstein*. Although Shelley's original novel had entered the public domain, Universal Studios immediately threatened lawsuits when Hammer Films announced the project. The script also raised production-related cost concerns for the B-movie studio. For its entire existence, Hammer Films was a small operation with a stable of production personnel moving from film to film together as they raced through low-budget production schedules. Few people blinked twice when production manager Jimmy Sangster was given the job of drafting a new Frankenstein script, in spite of the fact that he'd never written a screenplay before. His main marching order was to stay as far away as possible from any previous Frankenstein films. He also had to keep the film under the tight budget, which meant a small cast that didn't include torch-wielding villagers. The special effects would have to be limited as well.

Film noir director Terence Fisher was brought in to helm the picture, entering a new phase in his career at the age of fifty-four. The director had first worked with Hammer Films in 1952 on *The Last Page*, a noir film that was released in the United States as *Man Bait*. *The Curse of Frankenstein* (1957) was his first horror film. Although he'd never worked in the genre, after the movie opened, he would go on to direct twenty-three more films—eighteen of them for Hammer Films, and almost all horror movies.

By the time Fisher was attached, *The Curse of Frankenstein* was already planned to be Hammer Films' first color movie. In fact, it would be the first color horror movie released in Britain. Fisher balked at the three-week filming schedule and insisted on more time to produce a film in color. He was given just one extra week. In preparation for shooting, Fisher chose not to watch the 1931 film, preferring to focus on his own

It's Started!

THE CURSE OF FRANKENSTEIN

— STARRING —

PETER CUSHING

WITH

HAZEL COURT AND ROBERT URQUHART

AND

CHRISTOPHER LEE as the Creature

Screenplay by JIMMY SANGSTER Based on the Classic by MARY SHELLY

Produced by ANTHONY HINDS

Directed by TERENCE FISHER

A HAMMER FILM PRODUCTION IN EASTMAN COLOUR

The Curse of Frankenstein (1957) was film-noir director Terence Fisher's first horror movie.

vision rather than risk being influenced by a movie he was directed to steer clear of for legal reasons.

Heading up the small cast of *The Curse of Frankenstein* were Peter Cushing as Victor Frankenstein and Christopher Lee as the monster, two actors better known for their television work at the time. Cushing would go on to perform the role of Frankenstein in all but one of the subsequent sequels. As this small production house prepped for filming, they likely couldn't imagine that they were about to commit themselves to the characters for almost two decades.

Universal's claims of copyright on the monster makeup design prevented Hammer Films from mimicking Jack Pierce's famed work, which had become the established look for the creature. Hammer makeup artist Phil Leakey needed to come up with something cheap that looked good in color and that he could do quickly. Unlike Pierce, who performed numerous makeup tests with Boris Karloff to perfect the look, Leakey had about twenty hours to put together his concept before filming began. He would later

admit to being embarrassed by the makeup design he created, saying it was little more than "sticking lumps of flesh on a skeleton or skull" and then giving it the appearance of being stitched up. The makeup styling of the monster would not be followed for subsequent pictures. In fact, most future Hammer movies would have the monster looking more human than a deformed patchwork creation.

If the Universal *Frankenstein* films added to the monster's mythology, the movies by Hammer Films Productions completely deconstructed it. The series is notable for a number of reasons, not the least of which was its emphasis on violence and gore. Whether intentional or not, Hammer Films also succeeded in refocusing the narrative on Dr. Frankenstein, stealing it back from his monster. In fact, the monster is different in every movie, as Dr. Frankenstein's obsession moves beyond simply creating life. He wants that new life to be perfect in every way. Frankenstein isn't looking to emulate God, as had been alluded to in the past films and the original novel. This version of the character wants to *surpass* God's abilities. With that goal in mind, Dr. Frankenstein takes on the role of villain throughout the series, willing to do whatever it takes to achieve his goal.

The Curse of Frankenstein introduces this idea from the outset, with Frankenstein already in jail awaiting execution for what he claims are the

RIGHT: A movie poster promotes *The Revenge of Frankenstein* (1958), directed by Terence Fisher. OPPOSITE: Peter Cushing embraces the role of the mad scientist as Baron Frankenstein.

crimes of his monster. The story is set in the Victorian era and told in flashbacks, during which Frankenstein does admit to committing murder to obtain a superior brain for his experiment. But like Fritz's mistake of using an abnormal brain in the 1931 film, Frankenstein's pure gray matter also becomes a problem. During a struggle with his assistant, Paul, the glass container holding the brain falls and shatters. Although the scientist cleans the broken shards from the brain, he doesn't get all of them and implants a damaged mind into the creature.

Its damaged brain becomes the reason behind the murderous path it takes. It's a path that Frankenstein at one point encourages, leaving the monster to attack Justine, a servant blackmailing the scientist because she is pregnant with his child. Although Justine is a character in the original novel, the name is where their similarities end. This is also true of Elizabeth, Dr. Frankenstein's betrothed in the film. She ends up riding off into the sunset with Paul after the assistant refuses to corroborate the story about the monster to the authorities. The film closes with Victor Frankenstein being marched off to the guillotine, but that is far from the end of his story.

Hammer Films produced *Dracula* as its next horror feature, and then followed up with *The Revenge of Frankenstein* in 1958. Most horror fans consider it to be a much stronger film than *The Curse of Frankenstein*. The setup for the sequel is that Frankenstein avoided execution by convincing a hunchbacked prison employee named Karl that his mind could be placed in a new, perfectly functioning body if he helped in the escape. Three years later, "Dr. Stein" fulfills that promise. In the process, Karl's brain is damaged in the new body, creating a monster once more. This theme of implanting minds in new, superior bodies carries through the rest of the movies in the series in *The Evil of Frankenstein* (1964), *Frankenstein Created Woman* (1967), *Frankenstein Must Be Destroyed* (1969),

The Horror of Frankenstein (1970), and *Frankenstein and the Monster from Hell* (1974).

Thanks to a distribution deal between Hammer Films and Universal Pictures in the mid-sixties, the embargo on Pierce's classic makeup design was eventually lifted and the production no longer had to pretend that the classic Frankenstein movies never existed. Instead, they embraced the character's history in *The Evil of Frankenstein* with a story that was tied to the film *Frankenstein Meets the Wolf Man*. It is the only one of the studio's films that takes place outside of their existing continuity and the lone movie to re-create the classic monster makeup design. It is also one of the two Frankenstein Hammer films that were not directed by Fisher.

While the Hammer films were very popular—and remain so to this day—their audience falls more into enthusiasts of a specialized B-movie horror category. The films became cult classics; they were never truly mainstream commercial hits. The move toward more dramatic and critically acclaimed horror films in the seventies signified the end of an era for Hammer Films. Though the Hammer movies are important entries into the history of the characters, they didn't fully affect the pop culture mythology that had taken hold of Frankenstein's monster on a larger scale. But they are a key part of a film legacy that would continue far beyond the two movie studios that were preoccupied with the monster for much of the twentieth century.

ABOVE: La maldición de Frankenstein was the Spanish-language release of Hammer Films' The Curse of Frankenstein (1957).

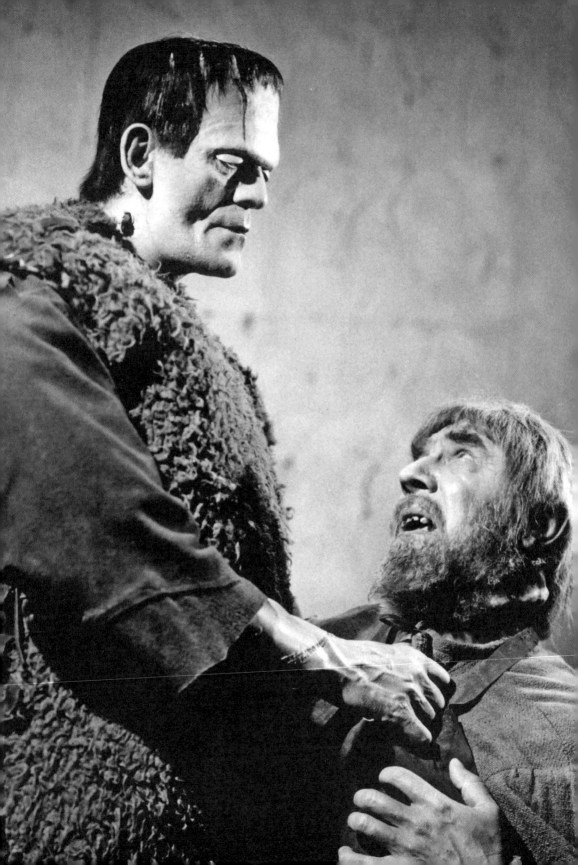

A MONSTER OF ALL MEDIA

Hammer Films Productions may have been ready to take over the Frankenstein legacy in the fifties, but Universal Studios wasn't quite done with it yet. As Hammer was gearing up film production, the still-blossoming medium of television was also heating up the race for audience eyeballs. The 1950s were known as the Golden Age of Television, and during this time, the major networks—NBC, CBS, and ABC—finally filled every day of the week with programming. It was also a time of great experimentation, leading to groundbreaking classics like *I Love Lucy*, *The Honeymooners*, and *Gunsmoke*. But for all those memorable hits, there were many, many misses. Filling seven days with content was challenging and expensive.

Producers of television programming looked to other venues for both inspiration and content to fill their airtime. At first, they were met with reluctance from established talent unwilling to take the risk on this new

OPPOSITE: Universal Pictures monster films were revived during the Golden Age of Television, and movies such as *Son of Frankenstein*, starring Boris Karloff as the monster and Bela Lugosi as Ygor, reached new audiences.

technology. Lots of people initially scoffed at the idea of television becoming a popular form of entertainment. Motion-picture studio executives and talent steered clear of this burgeoning competition for fear of the impact it would have on their audience. Even Broadway and vaudeville stars were slow to warm to it. Radio, the most profitable entertainment medium at the time, was also hesitant, but it was from within those transmissions that television would find itself.

Milton Berle, Mr. Television, paved the way for radio stars to become TV stars in the 1950s.

The earliest television productions took a page from radio, with many of the first TV shows mimicking the style of the audio medium and embracing its stars. Milton Berle, a midlevel radio celebrity, became the first bona fide TV star with the *Texaco Star Theater* that premiered in 1948. When the show launched, only 2 percent of households in the United States owned televisions. By the time it went off the air in 1956, that number had risen to over 70 percent, and Berle had earned the title of Mr. Television. Other radio stars followed. Talent from stage came as well, both Broadway and vaudeville. Most original programming took a lead from live stage productions, with variety shows at the forefront. By the mid-1950s, movie people came calling.

Producing television still wasn't cheap. Creating original content required a lot of money and effort. But radio scripts could be adapted for television production with some alterations, so shows began to make the jump from radio to TV, bringing their established audiences as well as their actors and writers—followed by new production crews, newly constructed sets, and new costs. Networks needed existing content that didn't come with all those added fees to balance their budgets. Luckily, that content was available. It just had to be modified to fit the small screen.

A FRANKENSTEIN IN EVERY HOME

In an age of video on demand and streaming media, it's easy to forget that there was a time even before DVDs and videocassettes when movies came to theaters for a

limited-release period, either made their splash or didn't, and then faded into obscurity. Sure, there were second-run theaters and sequels. People found ways to even bring film into their houses with expensive in-home film projectors, but this was not remotely common. It was a time before multiplexes, when a single film would be shown in a theater until it was evicted to make way for the next movie, and the next one after that. It was a period in which the 1910 version of *Frankenstein* could leave the screen and then be lost for decades.

Movie studios entered the TV industry in the mid-1950s, providing programming for broadcast networks and paving the way for a future in which film and television studios would ultimately merge. The studios didn't simply provide new content though. They also came loaded with libraries of entertainment: hours and hours of footage starring the biggest names in the most popular films. It was there for the taking—as long as the price was right. Syndication deals became the wave of the future, allowing networks to fill out their schedules and giving audiences the chance to watch movies they'd long forgotten or had never seen before, or loved and were excited to see again.

Syndication gave power to the local affiliates across the country. NBC, CBS, and ABC may have been the big players in broadcast television at the time, but they weren't the only ones responsible for occupying those broadcast schedules. Each city or media market had affiliates—usually independently owned by separate companies—that would enter into contracts with the networks to carry their content. But the networks didn't provide twenty-four hours' worth of content. Their

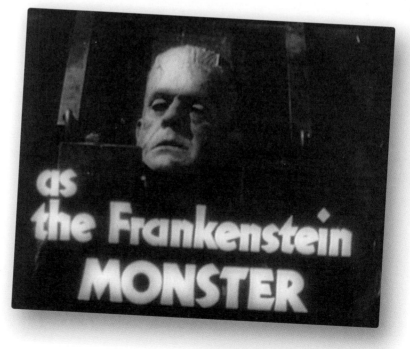

A frame from the *Shock!* television series' opening sequence featuring Frankenstein. The super-popular *Shock!* introduced the Universal monsters to a new generation of fans.

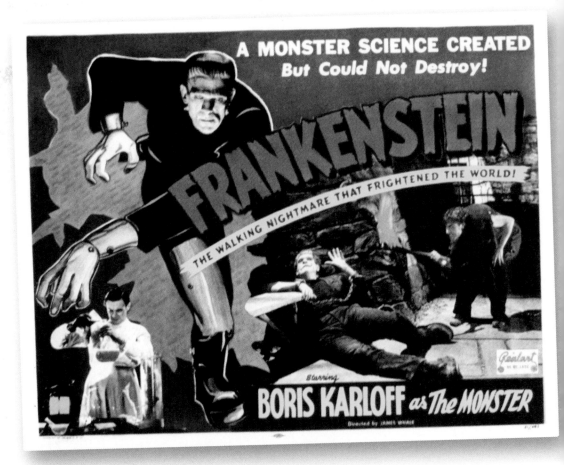

A movie poster for the 1931 *Frankenstein* starring Boris Karloff.

programming didn't even reach into late night, when viewership was typically down for obvious reasons. In the fifties, movie studios opened up their libraries to these affiliates, with Universal Studios' popular collection of horror films presenting an enticing package.

Screen Gems, a division of Columbia Pictures, had acquired the rights to fifty-two Universal horror films in a package titled *Shock Theater*, later simply marketed as *Shock!* All the Universal monsters were there: Dracula, the Invisible Man, the Mummy, the Wolf Man, and, of course, Frankenstein. The face of the now famous monster—embodied by Glenn Strange under the makeup—was one of the first promotional images for the package. The collection included the original 1931 film as well as *Son of Frankenstein* and *Frankenstein Meets the Wolf Man*. *Shock!* was a huge success in just about every market

when it started airing in fall 1957. But the draw for audiences was about more than just the classic films.

To help pad the film running times and introduce the movies, Screen Gems suggested some promotional stunts that affiliates could use to help entice viewers. Hosts were introduced across the country to welcome TV viewers to the movie and pop in during the commercial breaks with horror-themed skits that included monsters and mad scientists. In the mode of horror hostess Vampira, and with names like Mad Daddy, Mad Marvin, and Morgus the Magnificent, these entertainers became celebrities in their own right, some to be forever associated with the horror genre.

Even though *Shock!* aired as late-night television, much of its audience consisted of children staying up past their bedtimes. These youngsters weren't around to see the movies when they first came out in theaters, and they became a major force in a horror movement that was sweeping the country. *Shock!* was a huge success in America, inspiring a second horror syndication package in 1958, appropriately titled *Son of Shock!* The horror audience was becoming an army, and they needed a leader.

Vampira (Maila Nurmi) hosted TV broadcasts of horror movies on Los Angeles's KABC-TV. Vampira would go on to star in the 1959 Ed Wood Jr. film *Plan 9 from Outer Space*.

A FAMOUS MONSTER

With the advent of movies on television, something wonderful and new happened with Frankenstein (the monster) and all its ghoulish friends: They developed a fandom. It was a decade before *Star Trek* or *Doctor Who* would grace television screens, and twenty years before *Star Wars* burst out on film. Fandom for TV shows, movies, comic books, and even toy lines are commonplace today, but before the fifties, there were relatively few, outside of

Enter Igor

Igor is the most fascinating character in the Frankenstein legend, largely because he does not appear in any of the most significant entries. There is no hunchbacked, bumbling henchman or a lab assistant in any edition of Mary Shelley's masterpiece. He does not appear in the plays based on the story that came out in the first century of its existence. He's not in the Universal Studios films or the Hammer horror movies. And yet, by the time Mel Brooks's 1974 film *Young Frankenstein* spoofed everything about the Frankenstein legend, Igor (pronounced *Eye*-gor, at least for one joke in the film) was accepted as Frankenstein's famed assistant.

Shelley's story is very much about solitude, and not just in reference to the monster's lone existence. Frankenstein's experiment is performed completely on his own, without assistance. He refuses to admit his actions, and surely would not have an accomplice beside him to witness his unholy act. Although the construct of the tale is that Frankenstein is finally sharing his story with his new friend, Robert Walton, the bulk of the text is concerned with the scientist's obsession with secrecy. The character becomes a narrator, explaining his thoughts and actions in detail to the readers. That doesn't translate into a visual medium like theater or film unless the story is one long collection of monologues. This is probably the reason that Frankenstein was given an assistant in his very first stage appearance in 1823.

Richard Brinsley Peake's *Presumption; or, The Fate of Frankenstein* introduced Frankenstein's assistant, Fritz, into the legend. In fact, Fritz is the very first character to appear onstage. The servant is the only person allowed to witness Frankenstein's experiment. He's there because the scientist's friend Clerval pays Fritz to keep tabs on Frankenstein, not help him. Though Fritz is something of a buffoon, he has a wife and is not the loner outcast assistant that future incarnations of the character would take.

The 1931 *Frankenstein* introduced the hunchback element to the mythology when the production—and the 1927 play it was based on—brought back Fritz. This version of the character is a petulant instigator who tortures the young monster and becomes its first murder victim, paving the way for future assistants to future doctors Frankenstein. But none of them are named Igor.

A character named Ygor, played by Bela Lugosi, does exist in both *Son of Frankenstein* and *The Ghost of Frankenstein*. Ygor is a grave-robbing blacksmith who enlists the help of Frankenstein's son to create a new monster and take vengeance on those who sentenced Ygor to hang for his crimes. Ygor then goes on to provide the brain for that monster in the sequel,

OPPOSITE: Every mad scientist needs a right-hand man. Marty Feldman brought laughs with Igor, Dr. Frankenstein's odd assistant, in *Young Frankenstein*.

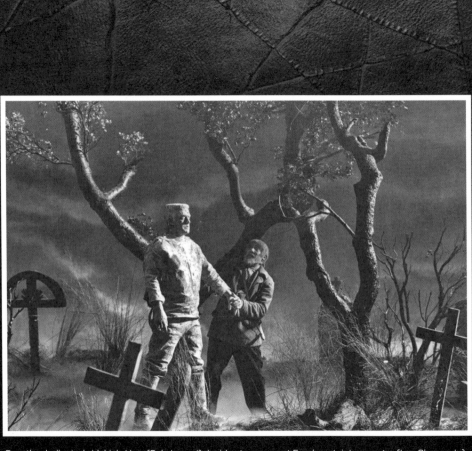

Ever the dedicated sidekick, Ygor (Bela Lugosi) decides to resurrect Frankenstein's monster (Lon Chaney Jr.) in *The Ghost of Frankenstein*.

The name stuck. Soon Igor was the go-to assistant to mad scientists everywhere, and Dr. Frankenstein in particular. He appeared in the aforementioned *Young Frankenstein*, as well as *Van Helsing* (2004) and *Victor Frankenstein* (2015). He's served Count Dracula in iterations of the vampire's tale as well. He even earned his own film in 2008 with the computer-animated Igor, in which his character was voiced by former teen heartthrob John Cusack. Igor is often bumbling, and rarely an intellectual, but he has become an indelible part of the Frankenstein legend and continues to serve his masters in a variety of horror-themed stories.

John Zacherle, host of *Shock!*, mixes things up between commerical breaks.

Forrest Ackerman was a pioneering fan who started a popular magazine titled *Famous Monsters of Filmland*. He's pictured (above) with the various heads of monsters, including Frankenstein.

children's programming. Universal's monsters—and the quickly growing Hammer horror films—were gaining an audience of both children *and* adults. These fans didn't just *enjoy* horror films; they were obsessed with the movies and characters. They wanted to learn everything they could about what went into the making of their favorite movies. And one man was about to deliver.

Forrest J. Ackerman is one of the earliest examples of a professional fan—that is, someone who turned an interest in a subject into a career. Already a noted science-fiction fan by the fifties, Ackerman's interests expanded to the world of horror when he served as editor and a leading voice in the first magazine devoted entirely to the subject of horror movies. But his role in the history of monsters—and Frankenstein in particular— was more than just a simple job. He, too, became a celebrity in the field. And it all started with that little magazine.

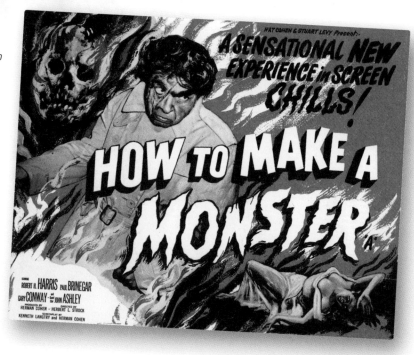

A poster promotes *How to Make a Monster* (1958), a teen horror movie. The genre gained popularity in the 1950s.

Long before the internet, people had to go to a newsstand to find out more about their favorite movies and stars. Hollywood tabloids were already popular; movie fans devoured all the gossip they could about celebrities. But they didn't focus on horror. That changed when Ackerman launched *Famous Monsters of Filmland* with publisher James Warren in February of 1958.

Originally conceived of as a one-shot, the magazine was not hurting for content. *Shock Theater* had launched in the fall, and *The Curse of Frankenstein* premiered almost a year earlier. The debut issue contained a brief history of the horror genre to date. It was filled with short articles about the films and summaries accompanied by publicity photos and original artwork—the gorier the better. It was a huge success that immediately went into a second printing and inspired the publisher, Warren, to turn it into an ongoing magazine with Ackerman at the helm.

Famous Monsters of Filmland was aimed at younger fans of horror, but the publisher wasn't squeamish about the subject matter. As editor, Ackerman also tweaked the traditional Hollywood magazine format. The tabloids that rose up in the thirties and forties—with gossip columnists like Hedda Hopper and Louella Parsons—focused almost exclusively on actors and actresses, the celebrities in front of the cameras. *Famous Monsters of Filmland* was one of the earliest publications to feature the behind-the-scenes talents, highlighting the work that went into crafting their monsters. Makeup designers, special-effects artists, and other below-the-line crewmembers were soon achieving their own level of fame. But the focus wasn't just on the newest batch of

A still from the movie *Earth vs. the Spider* (1958), another example in the popular teen horror genre sweeping the country.

genre films produced while the magazine was being published. *Famous Monsters* always stayed true to the classics.

When Boris Karloff passed away in 1969, Ackerman devoted an entire issue to the man who had defined the image of the modern-day Frankenstein monster. Fittingly, the cover was a shot of Karloff as his most famous creation, and it boasted interior pages that contained "his life in pictures," along with commentary from *The Bride of Frankenstein* co-star Elsa Lanchester, Vincent Price, and fellow Frankenstein performers Lon Chaney Jr. and Christopher Lee. The magazine opened with the simple statement: "BORIS KARLOFF: Born November 23, 1887. Died February 2, 1969. In between became a living legend and household name. Made 150 films and millions of fans."

The success of *Famous Monsters* inspired imitators, and it soon became a golden age for monster movies and the publications that wrote about them. Among its chief competition was *Castle of Frankenstein*, which launched in 1962 and followed a similar

format, while also featuring amateur filmmakers. Both magazines folded by the early eighties, but they made comebacks in 1993 and 2008 under different owners. No matter. The magazine paved the way for more genre titles, like *Fangoria*. And Forrest J. Ackerman, who passed away in 2008, was forever associated with genre fandom. As it says on his tombstone: "SCI-FI WAS MY HIGH."

HORROR MOVIE MARATHON

If Universal is considered the king of Frankenstein movies, then Hammer Films is the B-movie prince. But they are far from the only film studios that found a treasure in the monster. Other low-budget independent film studios, contemporaries of Hammer Films, were also cashing in on the popularity of genre entertainment. The rise of horror in the mid-twentieth century coincided with the rise of sci-fi—a natural pairing for Mary Shelley's gothic horror story that was one of the earliest works of science fiction. Another burgeoning "genre" during this time was the teen movie, meant for a new audience that was being serviced in various fields of entertainment. Horror, sci-fi, and teen genres converged with Frankenstein in the late fifties.

Beach party movies with Frankie Avalon and Annette Funicello were still a few years away, but in that era, teen horror movies were staking their claim with titles like *The Blob* (1958), *How to Make a Monster* (1958), and *Earth vs. the Spider* (1958, later renamed *The Spider*). Naturally, these films also mined classic characters with *Blood of Dracula* (1957), *I Was a Teenage Werewolf* (1957), *I Was a Teenage Frankenstein* (1957), and *Frankenstein's Daughter* (1958). These versions had very little resemblance to the classic literature the teens may have been reading in school.

I Was a Teenage Frankenstein was part of a series that began with *I Was a Teenage Werewolf* and culminated in *How to Make a Monster*. The stories weren't related, but the latter two films were a direct result of *Werewolf*'s success when a theater exhibitor requested more product from producer American International Pictures (AIP). The script for *I Was a Teenage Frankenstein* was dashed off, and the film went into production only a month after the request was made, premiering only five months after *Werewolf*. The movie, like *Frankenstein's Daughter* (1958), centers on a teenage girl who gets caught up in a mad scientist's plot.

Allied Artists' *Frankenstein 1970*, released in 1958, brought Boris Karloff back into the Frankenstein fold, with the acclaimed actor playing Baron Victor von Frankenstein, the last living descendant of the original Frankenstein. This mad scientist uses atomic power to bring his creature to life. At least this film had a tenuous bond to the original novel, which was more than many Frankenstein films made at the time. Shelley's

original work was largely ignored during this boon period in horror/science-fiction films, as concepts—and titles—grew stranger. The monster also continued to be quite sociable and made more friends with genre mash-ups like *Frankenstein Meets the Space Monster* (1965) and the Western-set *Jesse James Meets Frankenstein's Daughter* (1966). The latter was released as a double feature with *Billy the Kid Versus Dracula*.

In the sixties, other international productions took some of the spotlight away from Hammer Films as they wound down their Frankenstein movie series. One of the more notable entries was the 1971 Italian film *La figlia di Frankenstein*. The title may translate literally to "The Daughter of Frankenstein," but it was released as *Lady Frankenstein* in the US. The film mined the familiar content of Dr. Frankenstein working to reanimate the dead, but with the added twist of his daughter taking the lead in the tale after the monster kills the scientist. Japan got into the act as well, pairing Frankenstein with a successful *kaiju* subgenre with the movie *Furankenshutain Tai Chitei Kaijû Baragon* in 1965. Known in the US as *Frankenstein Conquers the World*, the movie has an unofficial title among the fandom: *Frankenstein Meets Godzilla*. Although not part of the famed Godzilla franchise, the movie does see an enormous lizard creature named Baragon take on a giant man-child that becomes known as Frankenstein.

The monster could not escape the so-called "blaxploitation" trend in the US during this time, either. Steeped in ethnic stereotypes, blaxploitation films were part of a

In 1966, Westerns met horror movies in *Jesse James Meets Frankenstein's Daughter*, which was released as a double feature with *Billy the Kid vs. Dracula*.

Frankenstein's Daughter (1958) captivated teen horror fans. The movie starred John Ashley and Sandra Knight.

movement to feature African Americans in movies targeted at "urban audiences." The intentions may have been good, but the results were sometimes questionable. Classic horror characters were first swept up in the trend with *Blacula* in 1972, in which an eighteenth-century African prince turned vampire is awakened almost two hundred years later to terrorize Los Angeles. The reviews were mixed, but the movie became one of the highest-grossing films of 1972, paving the way for *Blackenstein* the following year.

 Blackenstein the Black Frankenstein—more familiarly known as either *Blackenstein* or *Black Frankenstein*—tells the story of an American soldier who lost his arms and legs to a land mine while serving in Vietnam. His recovery is "aided" by Los Angeles–based Dr. Stein, who has a promising DNA solution that will help with limb-reattachment surgery. The experiment fails, the soldier loses his mental capacity, and his body becomes

FRSCO
PRESENTS...

NOT SINCE "FRANKENSTEIN" STALKED THE EARTH
HAS THE WORLD KNOWN SO TERRIFYING A DAY . . . OR NIGHT

BLACK FRANKENSTEIN

BLACKENSTEIN

A FRSCO PRODUCTIONS LIMITED FILM

WARNING!
TO PEOPLE WITH
WEAK HEARTS
NO DOCTORS OR NURSES
IN ATTENDANCE

STARRING JOHN HART, IVORY STONE. FEATURING ANDREA KING, LIZ RENAY, ROOSEVELT JACKSON, JOE DE SUE, NICK BOLIN, CARDELLA DI MILO, ANDY C. AND INTRODUCING JAMES COUSAR.
ALSO INTRODUCING MARVA FARMER

WRITTEN AND PRODUCED BY FRANK R. SALETRI EXECUTIVE PRODUCER—TED TETRICK DIRECTED BY WILLIAM A. LEVEY

COLOR BY DE LUXE

RATED R

Poster art promotes *Black Frankenstein* (1973), otherwise known as *Blackenstein*. It tells the story of a soldier injured in the Vietnam War who meets Dr. Stein, who says he'll help with limb-reattachment surgery.

deformed like the monster's that Boris Karloff made famous. The movie was not well received.

In the seventies, there was still a fair amount of camp, and some of the best *Frankenstein* comedies were made during this decade, but films were in the process of shifting beyond B-movies and exploitation. Frankenstein the man received his truest realization to date with the Swedish film *Victor Frankenstein*. The 1977 adaptation is considered one of the most faithful to Mary Shelley's work, although some changes—like the removal of the character Justine—were made to the story. The title was eventually switched to the much more grandiose *Terror of Frankenstein* to play up its horror-movie history over its literary credentials.

For the next few decades, Frankenstein bounced between dramatic reimaginings and more traditional horror tropes. Famed cult-movie producer-director Roger Corman got ahold of him in *Frankenstein Unbound* (1990). He created a film that wove together Shelley's personal life with her story elements to craft a futuristic science-fiction tale with time travel, based on a novel by Brian Aldiss. Bridget Fonda played the role of Shelley. Although Corman continued to produce films, this was the last movie he directed himself.

Frankenstein and his monsters starred in some amazing genre mash-ups. In *Frankenstein Conquers the World* (1965), the monster battles a Godzilla-like super-lizard called Baragon.

Frankenstein Reborn (2005) was another independent production, a modern-day retelling focusing on a cousin of Frankenstein, in what seems to be an ever-expanding family tree. Released in 2014, *Army of Frankenstein* (also known as *Frankenstein's Army*) is a low-budget mash-up of a film in which time travel sends multiple versions of Frankenstein's monster into the American Civil War. But not all versions of Frankenstein in the modern age were small, independent productions. In fact, the monster saw some of its largest scale representations around the turn of the new millennium.

In light of the success of the 1992 film *Bram Stoker's Dracula*, Kenneth Branagh took a turn with a monster, directing and starring in *Mary Shelley's Frankenstein* in 1994. Like director Francis Ford Coppola did with *Dracula*, Branagh also returned to the source material, attempting a faithful adaptation of Shelley's work while populating his film with talent like Robert De Niro in the role of the monster. The script by Frank Darabont does take some liberties, and the overall film wasn't well received by critics or American

audiences. Still, it performed well overseas and has become one of the more recognized film entries in the Frankenstein oeuvre.

I, Frankenstein kicked up the action a notch in 2014. This film, based on a graphic novel by Kevin Grevioux, starts off relatively true to the Frankenstein mythology before fast-forwarding to modern day. Frankenstein's creation, now named Adam, finds himself caught in an endless battle between demons and gargoyles. Producers hoped that the movie would do for the creature what the *Underworld* series did for vampires and werewolves, carrying them into a sweeping contemporary mythology. They also wanted to create a new monster universe that could cross over with the former movies. Critics did not enjoy the film, which is reflected in the 5 percent critics rating it holds on the Rotten Tomatoes website.

Not to be confused with the 1977 film that became known as *Terror of Frankenstein, Victor Frankenstein* was released in 2015. Starring James McAvoy as the titular character and Daniel Radcliffe as his assistant, this story is told in a new way: through the eyes of Igor. Here, Igor is elevated into something of an equal to Frankenstein, a partner in his experiments. The storyline might not follow Shelley's work directly, but some parallels and elements from the novel can be found in the production. The film reviews and reception were better than *I, Frankenstein*, but not by much, and the movie has largely faded from relevance.

THE MONSTER WINS ACCOLADES

The year 2023 was a significant one in the history of the Monster and its creator, both the scientist on the page and the writer behind the words. Hollywood came calling once again, seeking new and varied inspiration from the seminal work, and this time was rewarded with effusive praise and moviemaking's most prestigious awards. One might not immediately associate the creator of the atomic bomb with Dr. Frankenstein, but the idea of a scientist's all-consuming creation becoming his biggest regret certainly has an obvious parallel. *Oppenheimer* won Best Picture at the Academy Awards, along with a wealth of critical recognition.

Director Christopher Nolan's movie adapts *American Prometheus: The Triumph and Tragedy of J. Robert Oppenheimer*, the 2005 Pulitzer Prize–winning biography of the theoretical physicist who helped develop the US nuclear weapons program during World War II. The title of the book, written by Kai Bird and Martin J. Sherwin, is a clear connection to the complete title of Mary Shelley's work: *Frankenstein; or, The Modern Prometheus*. The extended name has dropped off the covers of most reprint editions over time, but it is a reminder that Mary Shelley's original story was an allegory for

Cillian Murphy stars in *Oppenheimer* (2023), a biopic about the modern Prometheus J. Robert Oppenheimer, the father of the atomic bomb.

the Greek mythological figure who defied the Gods to bring fire to the human world, in much the same way both Frankenstein and Oppenheimer brought world-altering creation and technology to humanity.

As time went on, it wasn't just the title of *Frankenstein* that changed in the public consciousness; the very concept of "Frankenstein" itself evolved as feminist retellings of the story have become more prominent in recent history. Another 2023 film, *Poor Things* is not an adaptation of Shelley's work, but it clearly draws inspiration from the source material with the tale of a gender-swapped resurrection that, like *Oppenheimer*, also received much critical acclaim and award-season love.

The 1992 novel *Poor Things: Episodes from the Early Life of Archibald McCandless M.D., Scottish Public Health Officer* by Alasdair Gray is the work upon which this *Frankenstein*-esque tale is based. In both the novel and the film, this female Frankenstein's monster is named Bella Baxter, a reanimated corpse that is brought back to life by Dr. Godwin Baxter (played by Willem Dafoe in the film).

Frankenstein gets a feminist take with the inquisitive and liberated Bella Baxter in *Poor Things* (2023).

His name is a clear allusion to Mary Shelley's own father, William Godwin. Bella is embodied by Emma Stone in the film, in an Academy Award–winning performance of the reanimated corpse brought back to life with the transplanted brain of the woman's unborn child. This makes her the embodiment of a mother with the naivete of her own child. It is notable that in Mary Shelley's *Frankenstein*, there is no female character, no mother to this child, and in *Poor Things*, a man is still responsible for creating this new life.

In the film adaptation, director Yorgos Lanthimos and screenwriter Tony McNamara made an important change from the novel by flipping the perspective of the narrator from the point of view of the male characters to Bella's. When seen from her perspective, this woman navigating her role in Victorian times serves as a commentary on the role of women in society today as Bella seeks to achieve both the intellectual and sexual freedom that she did not previously possess in her original life.

The journey that Bella takes in the story has been likened to the cultural tour that Mary Shelley and her mother, Mary Wollstonecraft, went through in their own time at the turn of the nineteenth century. In particular, the elder Mary's work for women's rights echoes through Bella's motivations in her tale. This is not entirely unlike the world tour of modern-day writer–pop star Taylor Swift, who spread her own message of female empowerment through her Eras Tour that began in 2023 and culminated in 2024.

It was during this tour, in April 2024, when Swift released *The Tortured Poets Department,* a collection of songs that includes a duet with Post Malone, called "Fortnight." Swift, whose body of work is studied at Ivy League universities, much like Mary Shelley's, incorporated gothic imagery and Romantic literary themes into her Eras Tour and infused much of her work on this album with literary influences. Nowhere is this more evident than in the video for "Fortnight," which Swift also wrote and directed. The black-and-white video depicts a tortured romance between Swift and Malone. The media accurately referenced the influence of the original 1931 film *Frankenstein* in the scenes set in a laboratory operated by mad scientists performed by Ethan Hawke and Josh Charles, who starred in the 1989 film *Dead Poets Society.* But it is Swift and Malone themselves who seem to embody the roles of Mary and Percy Shelley as they sit at vintage typewriters drafting what appears to be their next masterpieces but turns out to be tortured love letters to one another that echo the lyrics of the song. Their performances won Video of the Year at the MTV Movie Awards, as well as four other awards.

Later that year, pop music would more deeply embrace the monster with the release of the album *Playing with Fire* by JC Chasez. The former *NSYNC singer's first solo album in twenty years is a sixteen-track musical-theater concept piece inspired by a script for a theatrical adaptation of Mary Shelley's *Frankenstein* that never made it to the stage. Developed from the work of the late playwright Barbara Field, the musician partnered with Field's son, Jimmy Harry, to adapt her play into a musical. The album explores the original story's themes of love, responsibility, loss, and the human condition while modernizing the subject matter to provide commentary on current issues like the development of AI, a current-day monster built by humankind.

Frankenstein's film résumé would continue into 2025 and 2026, thanks in large part to the work of Netflix. The streaming service was behind two more adaptations of *Frankenstein* cinematic stories with A-list talent behind the scenes. *The Bride!* is a musical adaptation of the female partner to the monster, written, directed, and produced by actress and filmmaker Maggie Gyllenhaal. Meanwhile, a more classic adaptation of the original *Frankenstein* is helmed by horror-master Guillermo del Toro.

Starring Jessie Buckley as Frankenstein's (the monster's) bride and Christian Bale as the monster himself, *The Bride!* promised to be a high-caliber outing that could have

easily been seen as a gimmick. Originally funded by Netflix, the service gave up the rights during the 2023 Hollywood strikes, with Warner Bros. Pictures eventually picking up the option on the film. On April 4, 2024, Gyllenhaal released camera test images of Buckley and Bale on her Instagram account. The photos revealed more human-looking creatures—though still with references to the classic monster imagery—dressed in a 1930s aesthetic consistent with the film's time and setting. Buckley's hair in the color photo is a platinum blonde, expanding the familiar shock of white into full tresses, while Bale sports the familiar jagged scar running across his forehead in the black-and-white photo of him. Bale's prosthetic work is credited to makeup designer Nadia Stacey, who won an Oscar for her work on *Poor Things* at the Academy Awards ceremony that took place just a few days into the production on Gyllenhaal's film.

After Netflix abandoned *The Bride!*, they focused their attention—and financial support—on Guillermo del Toro's *Frankenstein*. The auteur-director has a long history with the monster and a very public love affair with Shelley's work. Influences from her masterpiece can be found throughout his résumé, culminating in his last pre-*Frankenstein* film that focused on the man-made life created in *Pinocchio*. Del Toro

A longtime lover of horror, Guillermo del Toro's classic adaptation of *Frankenstein* closely follows Shelley's masterpiece.

had previously likened the tale of the wooden boy to *Frankenstein*, citing that both "are primal experiences of what it is to be human" when discussing the movies that inspired him with the Motion Picture Academy.

The director's relationship with the original work at the heart of the adaptation was more than just an inspiration. He'd been trying to adapt Shelley's masterpiece for nearly two decades until finally partnering with Netflix after *Pinocchio* won the Academy Award for Best Animated Feature, also in 2023. Despite the well-known source material, the approach to the adaptation was a tightly held secret, leading to speculation based on the different iterations of the story del Toro said that he'd wanted to tell during the decades of development. Starring Oscar Isaac as Victor Frankenstein and Jacob Elordi as the Monster, as well as Mia Goth and Christoph Waltz, among others, the highly anticipated classic retelling would surely bring the master filmmaker's unique vision to a wholly new production.

As the filmography here has detailed, *Frankenstein*'s performance in horror and science-fiction films has been erratic over the decades. The monster has been a classic-film star and a B-movie mainstay, a terrifying creature and a sympathetic soul. The same has been true of television, where the monster flourished . . . and faltered. *Shock Theater* may have been a standout blend of film and TV, but it was far from the only time that the monster entered people's homes via cables and cathodes.

FRANKENSHOWS

Frankenstein's television tenure was more than just the rebroadcastings of theatrical films. The monster's history includes both movies made exclusively for TV as well as series work. In terms of the horror and science-fiction genres, its television presence has not been quite as notable as the film incarnations, but the creature has proven to be a versatile performer.

Anthology series, popular in the early days of television, were a perfect entry point. Shows like *The Twilight Zone* (1959–1964) and *The Outer Limits* (1963–1965) have had an impact on the science-fiction and horror genres and on television history, but one of the first anthology series to air was *Tales of Tomorrow,* which premiered in 1951 on ABC. The show delivered twenty-two-minute sci-fi and horror stories, mostly created by members in the Science Fiction League of America, like author Arthur C. Clarke, who would go on to cowrite *2001: A Space Odyssey* (1968) with Stanley Kubrick. In those earliest days of the medium, the show—like everything else on television—was presented live. One of the more notable episodes of *Tales of Tomorrow* was a half-hour adaptation of *Frankenstein* starring Lon Chaney Jr. in the title role.

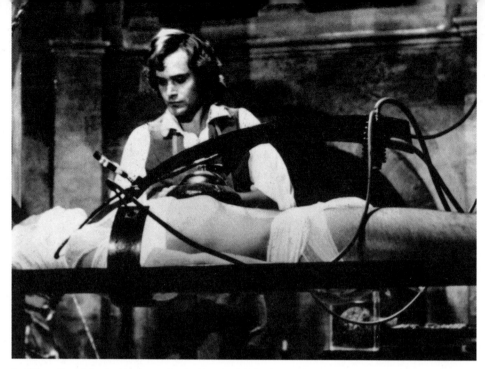

A still from the miniseries *Frankenstein: The True Story* (1973). The production was a joint British-American broadcast, coproduced by Universal Studios, which ran on NBC.

Chaney had inherited the monster movie-star mantle from his father, Lon Chaney Sr., who had been nicknamed "The Man of a Thousand Faces" for his work on silent-era films like *The Hunchback of Notre Dame* (1923) and *The Phantom of the Opera* (1925). The younger Chaney had already made his mark in the Universal monster franchise as the titular character in *The Wolf Man* series of films in the 1940s. He also starred as several other creatures, including a turn as the monster in *The Ghost of Frankenstein* (1942). Unfortunately, this outing under the makeup was memorable for all the wrong reasons.

Set in a remote island castle in the sixteenth century, *The Ghost of Frankenstein* is a fairly straightforward story. The plot follows the basic creation themes, but the monster's terror is contained to the castle, where it kills a maid while lumbering about on its own. Frankenstein's beloved Elizabeth and cousin, William, lure the creature into the lab, where it dies by electrocution—a fitting end considering how much electricity has contributed to its legend of being brought to life. As Susan Tyler Hitchcock reports in *Frankenstein: A Cultural History* (2007), the live production was significantly impacted by the star's alcoholism. Chaney was reportedly drunk during the broadcast, and the monster's lumbering about was not always scripted. Visibly confused and unclear on his actions, Chaney's performance was not a highlight of his career or in the monster's history.

That single performance did not deter others in any way from bringing the monster to the small screen. Though it would earn more praise for its televised comic outings, Frankenstein's monster made several other appearances in anthology series and television movies. While still experiencing some success with *Frankenstein* on the big screen, Hammer Films Productions partnered with Columbia Pictures to produce a television show called *The Horror of Frankenstein* in 1970. The concept was a cross between Hammer's traditional content and elements of the old Universal movies because Columbia held the television rights to the property at the time. This meant that their monster design could mirror the classic look created by Jack Pierce and brought to life by Boris Karloff. The pilot didn't sell, though, and the production struggled with conflict between the two studios.

In 1973, a two-part miniseries by novelist Christopher Isherwood and his partner, portrait artist Don Bachardy, promised the audience they would be watching *Frankenstein: The True Story*, but it only bore a passing resemblance to Shelley's tale. Interestingly, the script introduced a character named after one of the participants in the challenge at Villa Diodati, one Dr. Polidori, portrayed by actor James Mason. The cast also included Leonard Whiting, Jane Seymour, and David McCallum—it was a joint British-American broadcast coproduced by Universal Studios that ran on NBC. In this version, Frankenstein creates a perfect, new life that decays throughout the story, becoming the monster that audiences have come to know and love by the end. Avon Books published a tie-in novelization of the film based on the writers' original script.

Dr. Franken is another failed TV pilot that aired as a television movie on NBC in 1980. Starring Robert Vaughn and set in the then-present-day New York, the piece was "suggested by the Mary Shelley story." Originally titled *The Franken Project*, the plot follows a surgeon rebuilding the body of a patient with organs taken from the hospital where he works. This theme of contemporary settings continued with the 2007 British TV movie *Frankenstein*, which sees the main character become Victoria Frankenstein, a geneticist who creates a monster while attempting to clone her son so that she can harvest organs from the new body for the ailing child.

In 2015, two *Frankenstein* projects were developed for television as police procedurals. Both diverged from the original novel, and only one was met with a modicum of success. Fox's attempt brought a corrupt cop back to life in a body forty years younger. Originally simply called *Frankenstein* and then *The Frankenstein Code*, the show was in development when producers ultimately distanced themselves from the monster by changing the title first to *Lookinglass* and finally *Second Chance*. Only eleven episodes of the series were produced. Meanwhile, ITV's entry into the mythology, *The*

Frankenstein Chronicles, fared better, but with a rather interesting history. The critically acclaimed British show may have only had twelve episodes, but short-run series are standard for ITV, which produced two six-episode seasons starring Sean Bean. A period mystery, the series follows Bean's character, Inspector John Marlott, who is investigating a discovered corpse that has been created from the body parts of several missing children. Shelley has a role in this series as well, serving as a subject in the investigation. The show was originally intended to air in the US on the A&E Network, but somehow it never materialized until Netflix picked up the show and released it in 2018 as a Netflix "original" exclusive on the streaming site.

The Showtime and Sky television series *Penny Dreadful* is a critically acclaimed drama that combines a number of popular characters from the nineteenth-century novels that were a precursor to "pulp fiction." It weaves a tale that incorporates Dorian Gray, Dracula and his supporting cast, Dr. Jekyll, and Victor Frankenstein, along with the creature he creates. This Victor is a young, attractive man born of wealth who develops an addiction to morphine after relying on the drug to treat his childhood asthma. With a keen fascination for life after death, Victor creates his monster and then abandons it when he is horrified by his actions and the imperfect creature. This does not stop Frankenstein from attempting a second creature, which is killed out of jealousy by the first one. That monster then goes on to follow Shelley's original tale, forcing

In a dark twist on the *Frankenstein* tale, *The Frankenstein Chronicles* (2015) follows inspector John Marlott (Sean Bean), who finds a corpse assembled from the body parts of children.

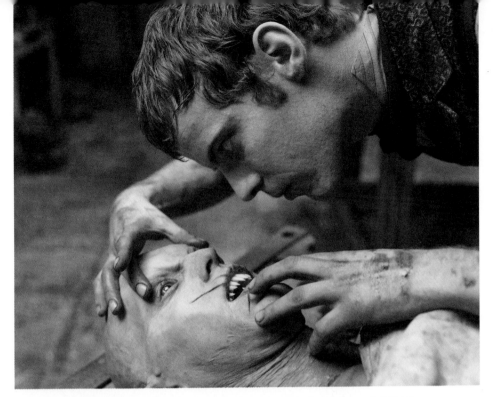

Victor Frankenstein (Harry Treadaway) is hard at work in an episode of *Penny Dreadful* (2014).

Frankenstein to make it a mate. *Penny Dreadful* ran for three seasons, winning several genre awards and being spun off into a tie-in comic-book series.

MONSTER BY ANY OTHER NAME

Frankenstein-like creatures have popped up in dramas and horror-themed shows in every decade, and not just in anthology series loosely based on Shelley's work. In this way, the Frankenstein monster has entered the public consciousness without the name being associated with the character. One of the longest-running characters inspired by the *Frankenstein* story was named Adam Collins on *Dark Shadows*. The 1960s soap opera was the first of its kind to present a story with traditional elements of daytime drama blending with gothic horror. The series centered on Barnabas Collins, a vampire in search of a cure for his affliction. That search leads him to Dr. Eric Lang, a modern Frankenstein in the process of constructing the body of a man to reanimate. Following the death of Lang, Barnabas gives life to the creature with the help of his ally, Dr. Julia Hoffman. They choose the name Adam for the new being, after the first man of biblical fame, and claim that he is a distant relative of the Collins family.

Adam shares some commonalities with the Frankenstein monster, though he deviates as well. Being a daytime drama, *Dark Shadows* cast handsome actor Robert

Rodan as the character. They left his looks intact, with only a few scars giving him a "monstrous" appearance. Like Shelley's creation, Adam starts out with a basic grasp of humanity but grows and learns along the way, becoming a fully fleshed-out person—notably with superstrength—who can speak, read, and fall in love. Like the classic creature, Adam becomes obsessed with finding a mate, causing Barnabas, Julia, and Carolyn Stoddard to help by creating one for him: the fittingly named Eve. Alas, his bride is just as uninterested as the original bride of Frankenstein, because the soul infused within this potential mate comes with a complicated past. Through a storyline rife with soap-opera elements of love and betrayal complicated by supernatural powers, Adam kills Eve and attempts to revive the body with a new soul. After eighty-two episodes, Adam ultimately leaves town for a surgery to remove his scars, allowing him to achieve a level of humanity that is rare for most of Frankenstein's monsters.

Two of the top genre series that premiered in the nineties—the science fiction–based *The X-Files* and the campy, horror-filled *Buffy the Vampire Slayer*—devoted several storylines to concepts that could easily have been inspired by the Frankenstein mythology. They also each produced an episode directly adapting the story, with their own twists.

The X-Files also drew inspiration from Mary Shelley in the episode titled "The Post-Modern Prometheus." In it, Scully (Gillian Anderson) and Mulder (David Duchovny) deal with a geneticist named Dr. Pollidori, who creates a genetically engineered "monster."

"Some Assembly Required" was a second-season episode of *Buffy* that aired in September 1997. An empty grave and body parts found around town lead teenage vampire slayer Buffy Summers and her friends to discover that a science-driven classmate is building a female body, hoping to create a mate for the dead brother he had already reanimated. The teen mad scientist and his undead brother ultimately choose erstwhile "friend" of the gang Cordelia for the finishing touches. Though the brothers initially fight the gang so their plan can proceed, the "monster," Darryl, eventually chooses to end his hollow life in a fire beside the body of the potential mate that was never completed. The writers of *Buffy the Vampire Slayer* later went on to create another "Adam" in a biomechanical creature constructed by a mad scientist named Dr. Maggie Walsh. This Frankenstein-type monster became the "big bad" of the series' fourth season.

Two months after "Some Assembly Required" aired, *The X-Files* ran "The Post-Modern Prometheus" episode. Pulling "Prometheus" from the full title of Shelley's work removed any question of inspiration for this story. A geneticist named Dr. Pollidori also ties it back to that small collection of friends at the Villa Diodati, where Frankenstein was first created. The fifth-season episode parallels Whale's film as well, with a genetically created "monster" blamed for a murder he did not commit. This being, named Mutato, meets a fate unlike most other representations when the angry townspeople realize he is not a murderous monster after all.

Each version of the Frankenstein story adds to the mythology, albeit in different ways. Some have a lasting impact, while others are overlooked. But new stories enhance the legend, pushing it beyond horror and science fiction, and even past drama, to find a home in comedy and cartoons. Because, like the monster itself has changed over the centuries, the storytelling has evolved as well.

FRANKENSTEIN BREAKS OUT

Frankenstein's evolution into a monster comedy star began fairly early on with the first play adapted from Mary Shelley's work, *Presumption; or, The Fate of Frankenstein*. Billed as a romance, it had to contain elements of burlesque, music, and spectacle because it was playing at the English Opera House and not one of the "legitimate" theaters of Covent Garden or Drury Lane. That venue was not licensed to present conventional dramas or comedies, and if Shelley's work had been adapted directly from the text, the theater would have risked being shut down. Most notably, the production added music to the story, which was something that had interested the monster in Shelley's tale. Several characters broke into song, and although the creature did not carry a tune, music always accompanied its entrances and exits. Another significant change was the infusion of comedy, with two roles created specifically for the play.

As discussed in the previous chapter, Frankenstein's servant-assistant Fritz was a new addition to the mythology, brought in to give the main character a foil with whom he could share his inner thoughts. But Fritz, along with his wife, Madame Ninon, also brought laughs. The older married couple served as a counterpoint to the young lovers in the romance of

OPPOSITE: A sitcom that grew from a *New Yorker* cartoon, *The Addams Family* featured a Frankenstein's monster—their butler named Lurch.

Presumption. They were traditional stock characters: a bickering married couple, spouting dialogue filled with double entendre and innuendo. At one point, the action of the story completely breaks to give Fritz and Ninon a scene of their own that seems to solely exist as a moment of comic relief. They banter and sing, with Fritz alternately insulting Ninon about her age while expressing his deep love for her in a playful dance to raise her spirits; it could easily be mistaken for a vaudeville routine if it had been presented a century later.

Frankenstein's monster does not take part in the humor, but it does witness the conclusion of the scene and the obvious adoration of these two comic characters. This is how the creature will often be involved in future comedic performances: as an outside observer, not an active participant. Comic characters circle the creature, the audience finding humor in its stone-faced reactions.

But often is not always, and the Frankenstein monster also takes part in some of the most uproarious comedic moments in its legend, even becoming a comedy

Though the movie was a sort of last gasp for the Universal monsters, *Abbott and Costello Meet Frankenstein* paved the way for more comedy-horror mash-ups.

Bud Abbott and Lou Costello Meet Frankenstein paired the comedy duo with Boris Karloff again.

television star in its own right. Those memorable appearances would come much later, and they would make the monster into something wholly new and unique in the *Frankenstein* legend.

FRANKENSTEIN IS EVEN MORE UNIVERSAL

The Universal Studios movie series founded on Dracula and Frankenstein ushered in an era of horror films that saved the motion-picture studio from financial collapse. But the film business is a fickle industry with more downs than ups and budgets that make every decision a huge risk. This is as true today in the era of multimillion-dollar pictures as it was back when the industry was still in its formative years. At midcentury, the monster movies of Universal were not the shining stars they had been in the thirties. By 1948, Frankenstein had already been the focus of six horror films, the last of which was released in 1944. Universal continued to produce horror films throughout that period, but they didn't star the big-name classic monsters of the early movies. Audiences were

In a scene from *Bud Abbott and Lou Costello Meet Frankenstein*, the Wolf Man creeps up on Costello.

into space aliens and bizarre creatures, like mole people and giant spiders. They also wanted to laugh.

In the postwar years of the forties, there were few bigger comedy stars than Bud Abbott and Lou Costello. Like the horror films of the thirties, these two comedic geniuses were also credited with saving the studio during another downturn in Universal's economic fortunes. Their act was simple and well established in comedy. Costello played the bumbling but loveable sad sack who always found himself in troubling—though hilarious—situations. Abbott was the straight man, an acerbic, bullying presence who somehow still had a soft spot for Costello's antics. No matter the names of the characters they portrayed, the roles remained basically the same through

the nearly forty films they starred in together. The humor was usually built off Costello's innocent naivete and general ineptitude.

The former burlesque performers first teamed up onstage in 1935, three years before their first known radio performance, when they joined the cast of *The Kate Smith Hour*. "Who's on First?" is unquestionably their most popular skit. The bit relies on puns based on the unusual names of players on a baseball team, like Who, What, and I Don't Know (third base!). Their first movie for Universal, *One Night in the Tropics*, came out in 1940. Over the next eight years, they would star in more than twenty movies, mostly for Universal Studios, with titles like *Buck Privates* and *In the Navy*. Their comedy went beyond the armed forces though. They visited the Wild West and the Middle East. They went to college, had brushes with high society, and filled any number of jobs, mostly blue-collar. And in 1948, they met the famed Universal monsters.

Bud Abbott and Lou Costello Meet Frankenstein was something of a last hurrah for the Universal monsters and the actors who portrayed them. The story followed the basic Abbott and Costello formula: The comedians play Chick Young (Abbott) and Wilbur Grey (Costello), two railroad baggage handlers charged with transporting a pair of crates to a local wax museum. Inside those boxes are reportedly the remains of Count Dracula and Frankenstein's monster. Wilbur and Chick are accused of stealing the museum property when those "remains" come to life and leave the crates of their own accord. For most of the film, only Chick is aware that the monsters are real, though he is blissfully clueless to the fact that he's been caught up in a scheme that could cost him his life. His seemingly out-of-his-league girlfriend, Sandra Mornay (portrayed by Lenore Aubert), is working with Count Dracula to secure Chick's brain for the monster, to provide the count with a pliable servant.

Frankenstein may have gotten a shout-out in the title, but the monster has the least amount of screen time of the classic characters. It is more of a mindless slave than the sympathetic character it had been in other Universal films bearing its name. It is also far from the only horror character to make an appearance. In addition to the comedy duo, the film stars Glenn Strange as the monster, Bela Lugosi as Count Dracula, and Lon Chaney Jr. as the Wolf Man (listed as "Wolfman" on the movie poster). Vincent Price also makes an uncredited—and unseen—cameo as the Invisible Man.

Strange had already played the monster in both *House of Frankenstein* and *House of Dracula*. Though lacking some empathy, his character in the comedy followed the mythology established in James Whale's first *Frankenstein* film. In fact, the horror characters were generally true to their genre throughout the movie: They were playing in a traditional horror movie. Abbott and Costello were the ones who brought the funny.

A Universal Monsterhood

There is something of a brotherhood to playing the Frankenstein monster; at least, there was in the early- to mid-twentieth century. After three outings under the makeup, the creature established by Boris Karloff in the Universal series was passed on to Lon Chaney Jr., Bela Lugosi, and finally Glenn Strange. Though Karloff was said to have hated the experience of filming as the monster, there is no question he held immense pride in the role and deeply respected the legacy he established for the character. He reportedly even tutored Strange in his performance when he took over the part. Just because Karloff was done with the monster didn't mean the monster was done with him. Something about the creature takes hold when certain actors go beneath the makeup. It stays with them throughout their career.

After *Son of Frankenstein*, Karloff continued to appear in films about the monster but always in other roles. That doesn't mean he never put on the makeup again. It happened for the 1947 movie *The Secret Life of Walter Mitty* starring Danny Kaye, based on James Thurber's short story. Karloff played Dr. Hugo Hollingshead, a psychiatrist who almost convinces Kaye's character that his daydreams are a result of his insanity. Karloff also played the role of a villain in those daydreams, donning the famed monster makeup after Universal granted the Samuel Goldwyn Company permission to use the trademarked Jack Pierce design. That scene was ultimately cut from the film, but no matter; it wasn't Karloff's final appearance as the monster.

In a Halloween episode of the television series *Route 66* titled "Lizard's Leg and Owlet's Wing" that aired in 1962, Karloff, Peter Lorre, and Chaney Jr. guest-starred in a story that was a tribute to the horror films of the thirties and forties. The episode broke the traditional format of the show, but it was a loving send-up to horror fans and the famed Universal films.

Karloff wasn't the only Universal Frankenstein to carry the character beyond horror. Chaney Jr. had his regrettable performance of the monster in the anthology series *Tales of Tomorrow*. Strange appeared three times in Universal films, and was probably the actor who became most associated with the creature after Karloff. In fact, photos of Strange in the makeup for *Bud Abbott and Lou Costello Meet Frankenstein* have become such familiar images that newspapers across the country accidentally ran his picture as the monster alongside Karloff's obituary in 1969. He never quite rose to Karloff's fame though. Strange did revisit the character in another comedic outing with Costello in *The Colgate Comedy Hour* in 1954. Almost a decade later, he was the monster again in the 1963 miniseries *The Adventures of the Spirit*, in an episode titled "Frankenstein's Fury."

OPPOSITE: Boris Karloff sits down for a snack on the set of *The Bride of Frankenstein* (1935).

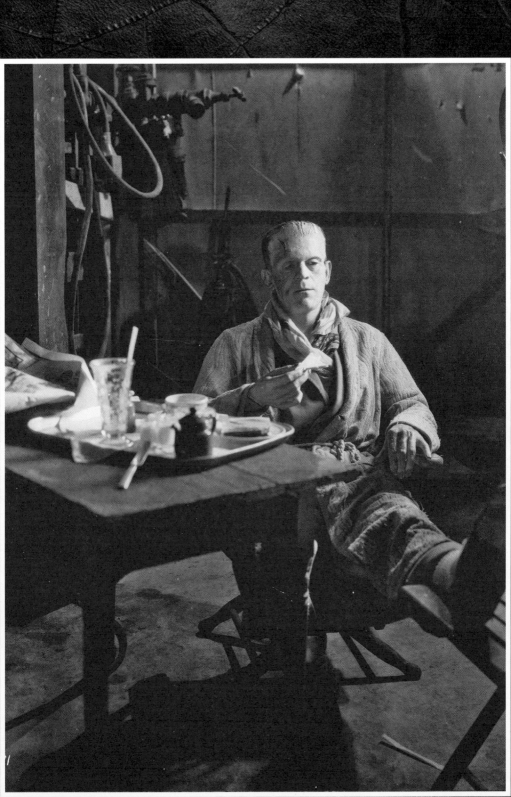

It was as if two films were fused into one. *Bud Abbott and Lou Costello Meet Frankenstein* helped to extend the monster's reach beyond horror, introducing new audiences to the mythology. But in this incarnation, Frankenstein became the ultimate straight man . . . or *monster*.

The film's dialogue is specific to note that the creature is Frankenstein's monster and not intended to be named Frankenstein itself. And yet, with no Dr. Frankenstein in sight, it's clear that the title is referring to the monster as the character that Abbott and Costello "meet." Costello's Wilbur cements this by referring to Strange's character as "Frankie" several times. Meanwhile, we see many familiar elements: Dracula uses electricity to wake the creature by sending jolts of power into the bolts in its neck. The monster lumbers about and has limited power of speech, with "Master" being the most freely formed word, largely in reference to Count Dracula. The monster even dies in a fire, much like its original ending in the first of its Universal films.

The comedy-horror mash-up was such a success (grossing over $2 million in 1948) that Abbott and Costello would later go on to meet the Invisible Man, the Mummy, *and* Dr. Jekyll and Mr. Hyde in their own films. But before encountering more Universal monsters, they met another famed *Frankenstein* performer. In *Bud Abbott and Lou Costello Meet the Killer, Boris Karloff,* Costello's character is falsely accused of murder, with Abbott trying to help prove his innocence. Karloff plays Swami Talpur, a character who (spoiler alert) is not the titular killer. In fact, it's a little unclear if Karloff's name was intended to be part of the title of the film or just the actor's credit—although the film poster seems to indicate the former. Karloff would later team up again with the comedic duo as the titular doctor in *Abbott and Costello Meet Dr. Jekyll and Mr. Hyde*, expanding on his horror résumé.

FAMILY MATTERS

September 1964 saw the debut of *two* new—and dramatically different—versions of Frankenstein's monster on television. They premiered within a week of one another in the most unlikely of places: half-hour family sitcoms. One had an established history in print. The other came with a pedigree tied directly to the Universal Studios horror films. Neither lasted for long on television, but they both continue to hold their place in pop culture today.

OPPOSITE: A promotional photo of the whole family together, in costume. *The Addams Family* featured, clockwise from the top left, Uncle Fester (Jackie Coogan), Gomez Addams (John Astin), Grandmama Addams (Blossom Rock), Lurch (Ted Cassidy), Pugsley (Ken Weatherwax), Morticia (Carolyn Jones), and Wednesday (Lisa Loring). Not pictured is Cousin Itt.

The Hanna-Barbera animated series *The Addams Family* (1992) was a popular Saturday morning cartoon option.

The Addams Family was the brainchild of Charles Addams, a cartoonist and a prolific contributor to *The New Yorker* magazine. His single-panel drawings relied on dark humor and included members of a macabre family that were more at home in a funeral parlor than in a living room. That basic concept evolved into the television series that would finally give them flesh and names. Headed by Morticia and Gomez Addams, the family included children Wednesday and Pugsley, Uncle Fester, Grandmama Addams, Thing, Cousin Itt, and their Frankenstein-like butler, Lurch.

It is never outwardly stated that Lurch—as played by Ted Cassidy—is an undead creature stitched together in some kind of science experiment. In fact, Addams went on the record, distancing Lurch from the famed monster. But that didn't stop the TV show writers—and writers on subsequent productions—from making several allusions to the monster. The supernatural ties of the rest of the family members are kept vague as well, with them being more *different* than defined. But the inspiration for Lurch is obvious as soon as he appears. The almost-seven-foot-tall butler is clearly intelligent, possessing the full power of speech, but his lines are generally minimal and sometimes his responses are little more than grunts. He has a particular affection for children, looking after Wednesday and Pugsley in much the way that Frankenstein's monster befriends Maria in the 1931 film (before the tragic turn of events). And, of course, his name comes from the style of movement most associated with the Frankenstein monster since Karloff's earliest performance of the creature on film.

The Addams Family ran on ABC for only two seasons, but it clearly made its mark. Lurch was a breakout character, with Cassidy appearing as the family's butler for a cameo on the TV series *Batman*. As *The Addams Family* theme music plays while Batman and the Boy Wonder scale a building, Lurch pops out of a window, which is a running gag on the show. Cassidy also recorded a song called "The Lurch" in 1965, appearing on the ABC dance show *Shindig!* to promote it and the dance move it inspired.

Lurch lived on beyond that show as did *The Addams Family*. The series spawned a pilot for a variety show, a reboot in the eighties with *The New Addams Family*, two animated series (in the seventies and nineties), a pair of motion pictures (*The Addams Family* and *Addams Family Values*), a direct-to-video movie, and even a Broadway musical in 2010. Lurch was there through it all, expanding on the mythology of Frankenstein with nary a mention of the monster, its creator, or any of the usual trappings.

Lurch and family—specifically one family member in particular—returned to the small screen again in 2022 with the Netflix series *Wednesday*, starring Jenna Ortega. Though Lurch, played by George Burcea, only appears briefly in the series, the allusions to Frankenstein's monster do not begin and end with what is essentially a cameo. Literary references abound throughout the series, which is largely set at Nevermore Academy, named in honor of horror master Edgar Allan Poe.

Wednesday takes center stage in Netflix's popular adaptation of the macabre teen.

Mary Shelley and her work make an appearance early on in the series when the botany teacher, Ms. Thornhill—played by Christina Ricci, Wednesday Addams in the original film—hands the protagonist a copy of the classic novel. Wednesday likens herself to Mary Shelley, whom she considers a "literary hero and nemesis" because she too is writing a novel and is envious of the fact that Shelley completed her seminal work by age nineteen. There are, of course, more direct allusions to the novel in the first season as Ms. Thornhill is later revealed to be the villain collecting body parts from the deceased in an attempt to resurrect the founder of the local town, making her reading recommendation a foreshadowing.

Beyond the allusions and the direct references in the first season, the Netflix series seemed poised to bring in even more of the monster into its second season. A casting announcement from the streaming site revealed a character named Karloff, who was described as a "young, athletic male teen" portrayed by an actor who would have to wear prosthetics. Although unclear at the time if the name was real or a temporary placeholder intended to inspire speculation, it was hard not to make the connection to Boris Karloff, the actor most associated with the Frankenstein monster in film history. Months after the casting announcement, it was revealed that the character would be played by Owen Painter, who was best known for his work in the Hulu miniseries *Tiny Beautiful Things*.

While the Addamses were somewhat outside of the normal nuclear family and possessed certain traits that clearly tied them to the supernatural, the core family members could pass as average humans, at least in appearance. Though the Frankensteinian Lurch would stand out in a crowd in more ways than one, he was also still overarchingly human. The family on the competing series, *The Munsters*, more physically resembled . . . well, *monsters*. This was, of course, by design. The situation comedy, which premiered less than a week after *The Addams Family*, was produced by Universal Television, sister company to the film division that brought classic creatures into public consciousness in the twentieth century.

The head of the household, Herman Munster, was Frankenstein's monster through and through. The flattop head, jagged scar on the temple, and bolts in the neck were clear callbacks to Pierce's famous trademarked design. The makeup also allowed actor Fred Gwynne's open and expressive face to shine through as he portrayed a character who possessed some of the creature's traditional naivete, but with full possession of speech and mental faculties. Though his wife, Lily (Yvonne De Carlo), was the daughter

OPPOSITE: *The Munsters* fused horror themes with the mundane. The Munster family didn't find themselves much different from their non-monstrous neighbors.

of Count Dracula—known lovingly as Grandpa in the series—her long raven-black hair originally contained a streak of white, a nod to Frankenstein's film bride. The family was completed by a werewolf-vampire son and the conventionally attractive cousin Marilyn, a beloved family member who was a black sheep due to her outsider appearance.

The series, created by the producers of *Leave It to Beaver*, followed a traditional format, save for the fact that this particular family living at 1313 Mockingbird Lane did not necessarily fit in with the rest of the neighborhood. But the Munsters weren't actual monsters, and Herman was more goofy than grotesque. His affable manner and slightly oblivious air were at the core of the show's humor. Herman's gullibility and genuine confusion over his interactions with people outside the family served as the inciting plot point for many episodes. The broad humor of the series often came from the reactions of those around a family that didn't really see themselves as all that different from their neighbors. Where *The Addams Family* often centered on dry, black humor—an element highlighted in the motion pictures based on the show—*The Munsters* was a lighthearted comedy.

The CBS television series was not a breakout hit at the time and, like *The Addams Family*, was canceled after two seasons. The studio didn't give up on the series entirely though, releasing the theatrical film *Munster, Go Home!* in 1966. Starring most of the original cast, the movie was intended to introduce foreign audiences to the characters, taking the black-and-white series into color. The movie was not a hit, but, like so many other genre shows of the time, the story of *The Munsters* did not end with the termination of the original production.

In syndication, the series came back to life. It found a new audience and grew immensely more popular. With only seventy episodes and the one movie produced, audiences were clamoring for more. Producers delivered with an animated episode of *The Mini-Munsters* in 1973 and a TV movie reuniting the adult members of the original cast for *The Munsters Revenge* in 1981. Entirely new casts populated the relaunched TV series *The Munsters Today* (1988) and new TV movies in the nineties with *Here Come the Munsters* and *The Munsters' Scary Little Christmas*. Popular TV writer-producer Bryan Fuller also took a stab at the classic characters in 2012 with the series *Mockingbird Lane*. Although the show wasn't picked up, the pilot movie did air on NBC, with Jerry O'Connell presenting a much more human-looking version of Herman Munster.

FRANKENSTEIN REMADE

It wasn't produced by Universal. It didn't share a cast, or a production team, for that matter, with the classic films. But there is no question that the 1974 comedy film *Young*

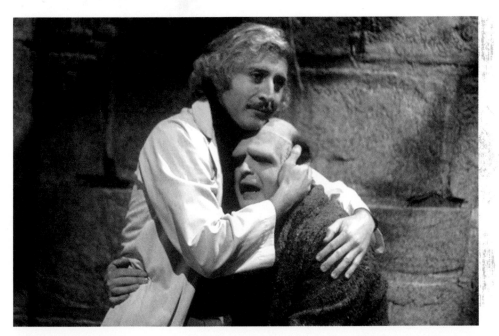

Dr. Frederick Frankenstein (Gene Wilder) embraces his creation (Peter Boyle) in *Young Frankenstein.*

Frankenstein owes its existence to the famed film series that premiered in 1931. The popular Mel Brooks movie took the mythology of Frankenstein that was created by Mary Shelley and cemented in pop culture by James Whale's two Universal Films (*Frankenstein* and *The Bride of Frankenstein*) and twisted it into a horror spoof for the ages.

The idea was born from the mind of actor Gene Wilder. It came to Brooks's attention when he saw the title in Wilder's scrawl at the top of a yellow legal pad while they were working on the film *Blazing Saddles*. After filming completed that day, the pair stayed up until five in the morning hashing out the concept for a comedic take on the *Frankenstein* legend. When production wrapped on *Blazing Saddles*, Brooks immediately turned his full attention to writing and directing their idea. Both films came out in 1974 and are considered by many to be the most memorable films of his stellar career.

Presented in black-and-white like the classics it pokes loving fun at, *Young Frankenstein* stars Gene Wilder as Dr. Frederick Frankenstein (pronounced *Frahnk-on-STEEN*), grandson of the original Dr. Victor Frankenstein, taking the character's name from the novel, not the film. A college professor and a scientist in his own right, Frederick has spent his life trying to live down his grandfather's reputation. But fate

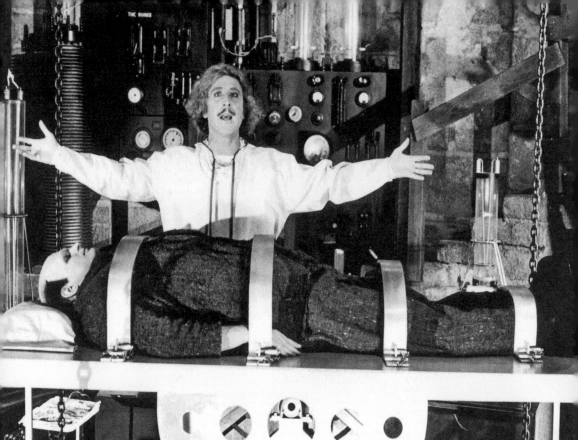

Dr. Frankenstein (Gene Wilder) in his laboratory in *Young Frankenstein* (1974). Much of the laboratory equipment was originally used in the 1931 James Whale version of *Frankenstein*.

would intervene when he inherits his family estate, a castle in Transylvania that comes with a staff as well as his grandfather's notes on his experiments reanimating the dead. That staff includes a tour de force comedic cast with a buxom assistant, Inga (Teri Garr); intimidating housekeeper, Frau Blücher (Cloris Leachman); and servant, Igor (Marty Feldman) in what could very well be the first time a character named Igor appeared in a *Frankenstein* story.

Quickly inspired by his grandfather's work, Frederick takes Igor with him on a mission to steal a corpse and then sends Igor out to find the perfect brain. Much like how Fritz made the mistake of destroying the proper brain and replacing it with an abnormal one in 1931, Igor does the same by choosing a brain he later refers to as belonging to one Abbie Normal. The creature they give life to, played by Peter Boyle, escapes the castle to go on adventures that mirror his predecessor's, though with less deadly results. For much of the film, the monster plays the role straight as the situations around it are filled with comedic characters; the humor comes from its limited

understanding of the world. Still, the monster manages to get in on the fun by taking part in a song-and-dance routine with Frederick as they try to convince their audience that Frankenstein's work was to be appreciated, not feared. This fails when a stage light blows, frightening the creature and sending it on a rampage that only ends with the police taking it into custody.

The monster escapes and unexpectedly unites with Frederick's fiancée, Elizabeth (Madeline Kahn), who is so impressed by its sexual prowess that she falls in love with it. A sexual encounter with the monster results in her hairstyle immediately changing to mirror that of the bride in the original *Bride of Frankenstein*. Meanwhile, Frederick transfers some of his intellect into the monster, making it more erudite. It doesn't exactly echo the manner in which the creature grows and learns in Shelley's tale, but the end result is the same. In this story, all the characters live happily ever after, including Frederick, who not only winds up with Inga but inherits a bit of the monster as well.

The story seamlessly blends Shelley's work and Whale's two films, while turning them on their heads. Key moments hearken back to the novel, beyond just the return of the original Dr. Frankenstein's first name. For instance, when Frederick reads from his grandfather's notes, he is reading an excerpt from the original text. The movie also includes visual throwbacks to the Whale films through the reuse of the actual sets. The production crew had gotten in touch with the special-effects artist Kenneth Strickfaden, who happened to have some of the original set pieces in his Santa Monica garage, and he rented it to the production for a reasonable fee.

This version of Frankenstein's monster is slightly deformed, but not as overtly horrific

Helping hands: Marty Feldman plays Igor, Dr. Frankenstein's assistant, in *Young Frankenstein* (1974).

as previous film versions. For a nice touch of humor, it includes a functioning zipper on its neck. Peter Boyle watched many of the classic Frankenstein films and styled his performance after the master, Karloff. It was a breakout performance for the actor, who would go on to later fame playing the patriarch of the Barone family in *Everybody Loves Raymond*.

In his book on the making of the film, producer-director Brooks admits that the initial two-hour-and-twenty-two-minute test screening for Fox studio personnel was not well received. They got laughs only about half the time. He asked the audience to come back in a few weeks, and immediately set to cutting the film down to ninety-five minutes. The audience returned to the tighter movie and loved every minute.

The true test of the film came with an audience that wasn't made up of studio employees, and it passed. The screenings for the general public were a success, and the trimmed-down film opened well when it premiered on December 15, 1974, ultimately earning $86 million domestically and Academy Award nominations for adapted screenplay and sound—all very notable achievements considering the film opened a day after *The Towering Inferno* and less than a week before *The Godfather II*. It only went on to grow in popularity as the years passed, with Brooks ultimately turning it into a successful Broadway musical in 2007, starring Shuler Hensley as the monster in a cast that included Broadway veterans Roger Bart, Megan Mullally, Sutton Foster, Christopher Fitzgerald, Fred Applegate, and Andrea Martin. The monster had come full circle on stage, starting out in a musical production of *Presumption; or, The Fate of Frankenstein* and rounding it out by "Puttin' on the Ritz."

A ROCKIER HORROR

Around the time *Young Frankenstein* was being conceived, the monster got one of its most extreme—and sexiest—makeovers thanks to a play that would become a film and then grow into one of the most beloved cult classics in history. Where *Young Frankenstein* was a tribute to the Universal monster movies, parody took on a new dimension in *The Rocky Horror Picture Show*. The rock musical was a ribald spoof of the B movies in the style of Hammer Films, pumping everything up to eleven with absurd characters playing out a ridiculous science-fiction plot.

The 1973 play *The Rocky Horror Show* was a surprise smash in London and proved to be popular in Los Angeles as well. When it hit Broadway in 1975, however, its fortunes came to an end. The New York production ran for only forty-five performances. Likewise, the 20th Century Fox film that also came out in 1975 was critically panned and initially failed at the box office.

The story is a complex send-up of B-movie science-fiction and horror films that begins when Janet and Brad, a seemingly typical couple played by Susan Sarandon and Barry Bostwick, experience some car trouble in a driving rainstorm. They seek shelter in the castle of Dr. Frank-N-Furter (Tim Curry), "a sweet transvestite from Transsexual, Transylvania." It is the night of the Annual Transylvania Convention and the time that the esteemed Dr. Furter—dressed in a corset and fishnet stockings—succeeds in bringing his own creation to life in a perfect specimen of a man named Rocky Horror. Through a series of deceptions and mistaken identities, Frank-N-Furter seduces both Janet and Brad, kills Rocky's partial brain donor, Eddie, and occasionally breaks into manically choreographed song-and-dance routines. Frank-N-Furter and his sister, Columbia, are killed when it is revealed that they and the servant characters of Magenta and Riff Raff are actually aliens. The "monster" Rocky then ascends the castle tower, carrying Frank's body with him as he plunges to his death.

The allusion to Frankenstein's name in Curry's character is obvious, but what is equally interesting is how Transylvania has now become indelibly tied to the Frankenstein legend. Like Igor, Transylvania appears nowhere in the original versions of the story. Shelley's novel takes place in Ingolstadt, Germany, as well as Switzerland, England, other points around Europe, and the Arctic Sea. The 1931 film is set in Goldstadt, a Bavarian town loosely based on Ingolstadt. The Hammer films are largely set in Switzerland. Transylvania was established as Dracula's realm in Bram Stoker's tale. By the 1970s, both *Young Frankenstein* and *The Rocky Horror Picture Show* tied the monster to that homeland as well, but *The Munsters* also counted the region that became Romania as "the old country" for the family of Herman Munster (which makes sense, since Grandpa was Count Dracula).

A promotional poster for *The Rocky Horror Picture Show* shows Dr. Frank-N-Furter in fishnets.

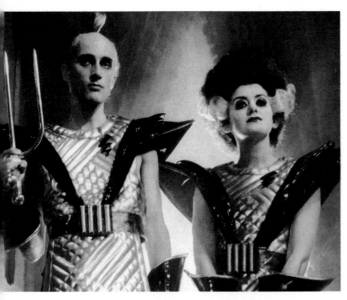

The titular Rocky of the film was unlike any Frankenstein monster that came before. His makeup was minimal, his clothing even less so. Embodied by professional model Peter Hinwood, Rocky is a blond Adonis who spends most of the film in nothing more than a gold bikini. For as much of his body that is seen in the film, it's what's missing that is interesting: Rocky doesn't have a belly button. After all, he was grown in a lab, not born or pieced together from body parts.

The Rocky Horror Picture Show didn't make much of a splash in its initial theatrical release, but it found a new life

ABOVE: Magenta (Patricia Quinn), pictured with Riff Raff (Richard O'Brien), sports the Bride's classic shocking hairdo.

BELOW: A Creation (Peter Hinwood) gazes adoringly at Janet Weiss (Susan Sarandon) in *The Rocky Horror Picture Show* (1975).

and tremendous cult success when movie theaters started midnight showings. As Fox proudly proclaimed on the movie's twenty-fifth anniversary in 2000, *The Rocky Horror Picture Show* had managed to become one of the longest continually running films in history. Once you see the film's devoted fan base, it was not hard to imagine why it never left theaters. It began at New York's Waverly Theater at midnight on April 1, 1976, and soon spread to movie houses across the country and around the world. The film became an interactive experience, with audiences shouting out new dialogue and throwing props at the screen. It spawned theatrical productions in which live actors would perform along with the film in front of the screen. A sequel called *Shock Treatment* followed in 1981, and Fox presented a reimagined version of the movie for television in 2016 with Laverne Cox as Dr. Frank-N-Furter and Staz Nair as Rocky. Somewhere along the way, the film gained critical respect as well, and it currently sits at 80 percent Fresh on the Rotten Tomatoes website.

A FAIRY-TALE LOVE

Frankenstein entered another genre in the new millennium when the doctor and his monster moved into the realm of fantasy with the ABC television show *Once Upon a Time*. The series, which premiered in 2011, followed the adventures of displaced fairy-tale characters Snow White, Prince Charming, the Evil Queen, and others cursed into the real world, initially unaware of their past identities. Most of the characters came straight out of the animated movie vaults of parent company Disney, with some exceptions, like Rumpelstiltskin and Little Red Riding Hood. But at least they were from the realm of fairy tales and lived in the Enchanted Forest. Dr. Victor Frankenstein, as played by recurring guest star David Anders, came from a Land Without Color that didn't necessarily promise a happily ever after. The doctor's true identity was not initially revealed to the audience. They only knew his real-world alter ego: Dr. Whale.

With the clear reference to director James Whale, the doctor's backstory was revealed, and there was little surprise. Blending the legend with fantasy, Dr. Frankenstein—and his assistant Igor—bring Victor's brother back to life with a heart stolen from the Evil Queen. She had wanted the doctor to use it to reanimate her lost love. When Igor likens the act to magic, Victor corrects him, noting that it is most assuredly science. Victor's brother comes back "wrong" and kills their father, forcing Victor to realize the error of his ways. When he tries to kill the monster he created, he is unable to—it's his brother, after all. *Once Upon a Time* adapted the Frankenstein story for the realm of fairy tales and put it in front of an audience that was formerly known as

The Monster Becomes a Sex Symbol

The Rocky Horror Picture Show is obviously a unique retelling, adding a little beefcake to the creature's legend, but it is far from the only time that sex has entered the picture. The homosexual overtones in the relationship between Frankenstein and his creation have been studied for years. Far beyond any academic pursuits, the idea of man creating a being he can love is a popular—if disturbing—theme in film. It's to be expected that a visual medium that places a heavy emphasis on sex would turn Frankenstein's legend into a more physical kind of tale.

What began with *The Bride of Frankenstein* also continued, but with different motivations for the creation of a new life—and that life was often female. Sometimes, the woman was created for the creature; other times, she was made for her creator. Sometimes, as in the case of the 1967 Hammer film *Frankenstein Created Woman*, it became a body-switching experiment in which the soul of a dead man was placed in the body of his deceased former love, giving life to a creature embodied by *Playboy* model Susan Denberg.

France embraced the Frankenstein legend with the 1972 release of a film whose title in English became *The Erotic Rites of Frankenstein*. It was a mishmash of a movie with sadomasochistic elements and very little plot. The film is notable for its portrayal of the male monster as a metallic-skinned creature that looks more like a robot than a patchwork of human body parts.

Flesh for Frankenstein, also known as *Andy Warhol's Frankenstein*, is a 1974 X-rated film produced by the pop artist. The production kicked up the sex and violence, presenting the gory film in 3D. In this unusual version, Baron von Frankenstein creates both male and female monsters in an attempt to develop a perfect Serbian race and provide release for various people's sexual needs.

Poster art for *Andy Warhol's Frankenstein*, an X-rated film presented in 3D.

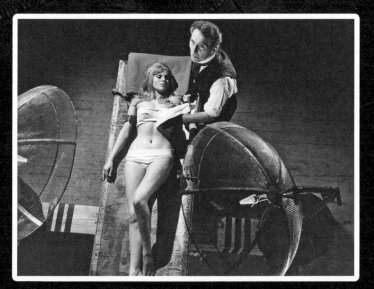

In *Frankenstein Created Woman* (1967), a Hammer film, the monster was played by *Playboy* model Susan Denberg.

One of the more popular reinventions of the story came out in 1985 with the film *Weird Science*, written and directed by famed teen-movie filmmaker John Hughes. The movie sees two teenage boys, played by Anthony Michael Hall and Ilan Mitchell-Smith, combine a computer, a doll, and some electricity to create the perfect girlfriend, embodied by model-actress Kelly LeBrock. Although the film was based on the short story "Made of the Future" from a 1951 issue of the *Weird Science* comic book, the plot reveals that the boys take their inspiration from the 1931 *Frankenstein* film. The movie received mixed reviews and wasn't one of John Hughes's more notable films, but it was a financial success that spawned a cult following as well as a hit song and even a TV series a decade after it left theaters.

The dark horror comedy *Frankenhooker*, released in 1990, follows a distraught man named Jeffrey looking to rebuild his deceased—and mutilated—girlfriend by completing her body with parts from prostitutes he killed. The monster he creates, played by former *Penthouse* model Patty Mullen, then does the same when Jeffrey is killed by a pimp. Because the process only works with female bodies, Jeffrey reawakens in a body also constructed from the parts of various ladies of the evening.

Bikini Frankenstein is pretty much what it advertises. This erotic movie made for the Cinemax cable network in 2010 took elements from the book and other movies and TV shows to have Dr. Victor Frankenstein move to Transylvania, where he brings life to a female creature he names Eve. The tagline for the soft-core film that featured some hard-core actors was "She'll Love You to Pieces."

the "family hour" of television. But by this time in the character's history, *Frankenstein* as a child's tale was nothing new.

GIRL POWER

Several years after the fairy-tale Frankenstein appeared on the small screen, two somewhat different versions of Dr. Frankenstein were back in theaters, bringing a female teen perspective to the role of reanimator. First was 2023's *The Angry Black Girl and Her Monster*, starring Leya Deleon Hayes, an actress best known for providing the voice of a very different doctor, namely Doc McStuffins in the animated series of the same name. Written and directed by Bomani J. Story, the science fiction–horror film explores themes impacting the Black community when the brother of the teen scientist Vicaria (Hayes) dies as a result of gang violence and is resurrected by his sister

in a modern reinterpretation of the monster's tragic existence. The ties to Mary Shelley's work are both felt and seen throughout the film, including the words "The Modern Prometheus" written across Vicaria's journal. The movie was not a commercial success, but Hayes's performance as the teen scientist did win critical praise.

Led by a teen scientist, *The Angry Black Girl and Her Monster* (2022) tackles themes impacting the Black community.

A year later, just in time for Valentine's Day 2024, the rom-com–horror film *Lisa Frankenstein*, written by Academy Award–winning screenwriter Diablo Cody, took the creator's story in a very different direction. The "doctor" is another teenage girl from an earlier decade. Kathryn Newton plays Lisa Swallows, a 1980s teen obsessed with a dead boy from the Victorian era portrayed by Cole Sprouse. More specifically, she is obsessed with the chiseled statue of the boy, who reaches teen heartthrob status in her eyes. The

The teen horror film *Lisa Frankenstein* puts an eighties spin on the *Frankenstein* tale with a nod to Shelley's husband.

"coming of RAGE" love story takes a Shelley-esque turn when that boy is brought back to life via lightning strike, although he is missing several body parts. The pair piece him back together by using the body parts of their victims acquired during a violent spree in which they attack those who have wronged Lisa. The film ends with Lisa herself being resurrected as the ceature reads Percy Shelley's poem "O Mary Dear" aloud.

Showing clear influences from the John Hughes films of the eighties—most notably *Weird Science*—this was not Diablo Cody's first time finding inspiration in a story of resurrection. Her 2009 film, *Jennifer's Body*, explored themes of female empowerment through the intentionally over-the-top plot of a possessed teen who kills her male classmates and consumes them to survive. Both films explore humor in the macabre to explore deeper themes of the inherent power imbalance between the sexes through campy, yet violent, escapades.

Although neither *Lisa Frankenstein* nor *The Angry Black Girl and Her Monster* were breakout hits, both movies have had their impact on Mary Shelley's legacy. When viewed alongside other modern reinterpretations, like *Poor Things*, *The Bride!*, and Taylor Swift's music catalog, they combine to create a period focused on the impact of the female creator of the monster. Through comedy and horror, literary allusion and musical interpretations, Shelley's work carries on her mother's legacy of focus on female empowerment that is only now just breaking through some two hundred years after the publication of her groundbreaking tale.

FRANKENSTEIN FUN

Boris Karloff received mountains of fan mail from children writing to him about his most famous character, a monster in a horror movie originally intended for adults. Over time, *Frankenstein* developed a loyal following among younger viewers, especially once it began airing on television as a part of *Shock Theater* in the fifties. It didn't matter that the creature was a murderer, or that it actually (though accidentally) kills a child. The young letter writers empathized with the monster. They saw themselves reflected in a misunderstood newborn that did not fully grasp the world around it; who wasn't always responsible for its own actions; and who could not convince adults that its accidents, though horrific, weren't intentional.

And so, strangely enough, Frankenstein the monster grew to become a part of childhood. Most kids today haven't seen the 1931 movie, and certainly haven't read the literary work. But the image of the flattopped, scarred, green monster with bolts in its neck is now commonplace, particularly around Halloween. To these young fans, Frankenstein *is*

OPPOSITE: The reanimated monster becomes animated. *The Nightmare Before Christmas* (1993) weaves in elements from Mary Shelley's original masterpiece.

the monster—a character as familiar to them as Mickey Mouse. They know it by any number of nicknames and personalities that are nothing like the conflicted character that Mary Shelley created. They appreciate it as an outsider that doesn't quite fit in. And they laugh when it performs slapstick comedy in a cartoon or children's show. For as many different versions of Frankenstein as there are in film and television for adults, there are just as many—if not more—versions for kids.

Frankenstein's monster started appearing in cartoons long before animated shows began airing on television. It's been a character in children's books with no ties to the original literary work, a toy, a breakfast cereal, and it's even shown up on candy wrappers. Whatever the incarnation, the monster isn't just fuel for nightmares. More often than not, the Frankenstein monster aimed at children is as much a child as the viewers, though one in a hulking adult body. Sometimes, it's just a straight-up comic character. The cartoonish version is so ingrained in childhood that many kids today are completely shocked to discover, when they are assigned to read Mary Shelley's original work in school, that Frankenstein is not actually the monster's name.

SATURDAY MORNING MONSTER

From the moment the image of Boris Karloff as Frankenstein's monster appeared on screen and in pop culture, the signature Jack Pierce makeup permeated public consciousness. Though the look was trademarked to Universal, it wasn't long before it was the accepted appearance for a character that had already existed for over a century without an established style. Only two years after the movie was released, the famed character Karloff gave body to was drawn into its first animated short. But it wasn't for Universal. This one came from the house of the mouse.

The Walt Disney Company's animated short *Mickey's Gala Premier* was released in 1933. The mini-movie delivered what the title promised: a Hollywood movie premiere for Mickey Mouse's latest film at the famed Grauman's Chinese Theatre. It was a show within a show in which audiences saw the latest adventure starring Mickey, Minnie, and the villainous Peg Leg Pete, while they also had a front-row seat to the premiere itself, watching animated versions of the Hollywood hoi polloi walk the red carpet and enjoy the film as well. All the big names turned out in these caricatures of the top talent of the time: the Barrymores, Laurel and Hardy, the Marx Brothers, Mae West, and many more graced the screen. The famous audience members laugh, cheer, and sway along with the music as reaction shots of the celebrities populate the short—until they literally roll in the aisles with laughter.

Hanna-Barbera's version of the Frankenstein tale, titled *Frankenstein Jr. and the Impossibles*, saw the monster as a robot who helps fight supervillains.

Among the famous faces is also a trio of legendary creatures: Dracula, the Wolf Man, and Frankenstein's monster, leaning in together and laughing. Though it's a momentary cameo—a blink-and-you'll-miss-it moment in what turns out to be Mickey's dream sequence—the monster is a clear homage to Karloff's portrayal. But the creature isn't in character as a *monster* but rather as a part of the Hollywood industry, like all the other actors and actresses. Future monster appearances would see it as both a villain and a hero, but most often as a lovable lug.

The sixties brought a notable rise in the monster's content for kids, likely growing out of *Shock Theater* rejuvenating interest in the character and introducing it to a younger audience. In 1964, *The Munsters* also brought a new version of the classic monster embodied in a kid-friendly way. The show may have lasted only for two seasons on CBS, but it was a hit with children. Munsters merchandise populated toy-store

shelves targeting young viewers: Herman Munster's face was emblazoned on dolls, puppets, puzzles, and more.

Six months before *The Munsters* aired, Warner Bros. had come out with their own theatrical short starring their biggest-name animated star. *Dr. Devil and Mr. Hare* put Bugs Bunny in the role of mad scientist, creating a robotic version of a monster whom he calls Frankie (and the rabbit sounds slightly like Lou Costello when he does so). Frankie not only attacks the Tasmanian Devil offscreen, but he goes after Bugs as well. Everything ends with the rabbit uttering the familiar line "Is there a doctor in the house?" Though this version of the story has a doctor, he certainly isn't named Frankenstein.

The latter half of the sixties saw something of a mini-explosion in family-friendly creature content, beginning with 1965's *Milton the Monster*. With nary a reference to Frankenstein (the doctor *or* the monster), this flattopped creature was made by Professor Montgomery Weirdo and his assistant, Count Kook. Though Weirdo intended to make an evil creature, he gives his creation an accidental overdose of the "tincture of tenderness" and turns it into a loveable goof. A more direct—but still completely unique—entry in the monster's history came a year later with *Frankenstein Jr. and the Impossibles*. The Hanna-Barbera Saturday-morning cartoon was actually two different cartoons presented as one; *Frankenstein Jr.* was sandwiched between episodes of *The Impossibles*. This Frankenstein is a blue robot who helps a father-and-son team of scientists named Conroy fight supervillains. The robot, Frankie, is the only character named Frankenstein in this series. And it turns the classic character into a superhero—one of the more dramatic departures from the legend.

Famed animation producers Arthur Rankin Jr. and Jules Bass added to the *Frankenstein* story with *Mad Monster Party* (sometimes written as *Mad Monster Party?*), a theatrical release in 1967. The stop-motion musical comedy placed characters from *Frankenstein* in an entirely new and rather zany tale that depicted a range of classic monster characters as guests at a party hosted by Baron Boris von Frankenstein. This Frankenstein not only shares a name with Boris Karloff but was voiced by the actor as well, in what was his last role directly associated with Frankenstein. Here, the monster is occasionally called Fang. Its mate, voiced by Phyllis Diller, proves to be a considerably more intelligent creature. The ninety-five-minute stop-motion animation film was never as popular as the other Rankin and Bass holiday specials like *Rudolph the Red-Nosed Reindeer* (1964) and *Frosty the Snowman* (1969), but *Mad Monster Party* has a cult following. It received a traditional-animation prequel, *Mad, Mad, Mad Monsters* (1972),

Vincent Price toned down the horror to introduce the kid-friendly series *The Hilarious House of Frightenstein* (1971).

released as part of *The ABC Saturday Superstar Movie*, bringing *Frankenstein* to animated television once more.

FRANKEN-TUNES

Frankenstein has been set to music from its earliest beginnings on the stage right through to the modern production of *Young Frankenstein* on Broadway in 2007 and the reimagined *The Rocky Horror Picture Show* on television in 2016. Kids got their own musical version of the monster in 1971 with *Sabrina and the Groovie Goolies*, a spin-off of *The Archie Show* (aka *The Archies*). Promoted as *The Sabrina the Teenage Witch Show*, which was based on the Archie Comics character, the Groovie Goolies were entirely new creations with no comic-book counterpart. They did interact with Sabrina in the series on occasion, but they had their own adventures before the characters split into two shows the following season. The adventures of these Groovie Goolies included a lot of singing, because these characters—headlined by Drac, Wolfie, and Frankie—were a pop band.

The Goolies were designed in homage to the Universal Studios horror creations. Frankie—as was becoming his go-to kid-friendly name—is a green-skinned, oversized monster dressed in undersized clothes. And he has the ever-present flattop head—of course, the most notable callback to the Pierce makeup. Frankie rocks out on a combination xylophone–drum set made of bones. He also has a tendency to get struck by lightning, which always proves to be a refreshing experience for him. Though the show never took off in its original airings, like many other incarnations of the monster in entertainment, it did develop a cult following. Even today the series continues to leave its mark: the Goolies name has been adapted for use in the Archie Comics–inspired TV series *Riverdale*, which launched in 2016. This time the name refers to a gang that is clearly human, though there has been one (possibly joking) reference to cannibalism in the dark-toned TV show.

At the same time as *Sabrina and the Groovy Goolies* was airing on CBS in the United States, Canada had its own children's program showcasing the monster. *The Hilarious House of Frightenstein* was another mishmash of horror characters in a uniquely comic, kid-friendly setting. Here, Count Frightenstein, the inept thirteenth son of Count Dracula (which in itself raises questions), was the star of the sketch comedy show. The basic premise of the series is that the count has been banished from Transylvania to live in Castle Frightenstein in the land of Frankenstone with a single mission: to revive a monster known as Brucie, who is without question related to Frankenstein's monster in some way. Count Frightenstein's green-skinned assistant, Igor, further added to the mythology, just three years before the character would have his most notable big screen outing in *Young Frankenstein*. Nearly two hundred episodes were produced in this series, which featured introductory voice-overs provided by horror master Vincent Price.

The monster appeared with some of his usual horror friends in episodes of *Scooby-Doo.*

Going by both the names Frankenstein *and* Frankenstein's monster, the creature continued to cameo past its heyday in the sixties and seventies. And it did so in notable animated TV series and movies far beyond what appeared on Saturday mornings. Along the way, it continued to make new friends—and enemies—as it met the Super Friends, Scooby-Doo, the Power Rangers, and Alvin and the Chipmunks. It appeared in animated offerings geared toward adults as well, like *The Venture Bros.* and *Robot Chicken*; it even headlined the Adult Swim stop-motion series *Mary Shelley's Frankenhole,* one of the

few times the source material was even acknowledged in animation.

Most of the time, Frankenstein shows up in children's shows in comedies or action-adventures, or a mixture of the two. But producers of children's programming weren't afraid to use the character in an educational setting as well. While the "horror" character has appeared on the classic seventies television show *The Electric Company* and the evergreen series *Sesame Street*, it also had a uniquely educational airing in 1995,

Bringing literary classics to a younger audience, the series *Wishbone* focused on Mary Shelley's *Frankenstein* in their episode "Frankenbone."

and tying directly to the original Mary Shelley tale for a change. This time, the star of the story was a dog.

The *Wishbone* books and PBS television series of the nineties retold classic literature for a younger audience. The star of the show just happened to be a Jack Russell terrier who was promoted as "a little dog with a big imagination." Each adventure centered on the pooch daydreaming about being the hero of a famous tale. The series featured novels that ranged from traditionally kid-friendly literature to more mature works, including *The Adventures of Tom Sawyer*, *Treasure Island*, *Romeo and Juliet*, *Faust*, *A Tale of Two Cities*, and *Great Expectations*. The series' take on *Frankenstein*, in an episode called "Frankenbone," stays somewhat true to the original but trims it down considerably to fit the time frame and portray the plot in an appropriate manner for the younger audience. In his daydream, Wishbone is Dr. Frankenstein, using multiple jolts of electricity to bring to life a monster that looks more human than most other incarnations.

THE TRANSYLVANIA TWIST

One of the more popular kid-friendly outings for Frankenstein (the monster) can be found in the most unlikely success stories in the billion-dollar *Hotel Transylvania*

Kid Tested,
Monster Approved

Breakfast cereal has been the natural companion to Saturday morning television for kids pretty much since the first cartoons aired on weekends. The popular dietary staple has been giving kids and their parents a boost since the nineteenth century when it started out as a healthy breakfast food. Sugar entered the picture in the early-twentieth century with Frosted Flakes. As the decades passed, sweet became a prime selling point for the product, particularly when targeting younger eaters. Fun cartoon characters entered the mix to entice children with bright colors, soon-to-be familiar friends, and, of course, the toy surprises inside. Tony the Tiger, Quisp, and Cap'n Crunch became recognizable faces. An explosion of marshmallow-filled cereals happened in the seventies, and they were marketed by loveable characters as sweet as the contents of their boxes.

General Mills built on the marketing technique in 1971 with the introduction of Count Chocula and Franken Berry, a pair of cartoon monsters clearly inspired by Universal's famous incarnations of the classic characters. Franken Berry, the cereal, was originally marketed as "a sweet strawberry cereal + marshmallow bits." Franken Berry, the character, is a pink, flat(ish)-topped monster with bolts on his neck and a steam whistle and pressure gauge for ears. In the earliest commercials, Franken was voiced by Bob McFadden in the style of Boris Karloff's famed baritone. Count Chocula and Franken Berry proved so popular that the ghostly Boo Berry was added two years later, making a monster trio that has been stocked on grocery store shelves for over forty years. A werewolf named Fruit Brute joined the monster cereal family in 1974, and Yummy Mummy was introduced in 1988. Neither stayed for long, but they did make brief returns to the line over the years.

Franken Berry's look has rarely changed in the past decades. Even when it was restyled in 2014 by comic book artist Dave Johnson of Deadpool fame, he still had the familiar aesthetic—and clothing—that the character launched with in 1971. The new styling was for a limited-edition set that included comic strips of Franken Berry, Count Chocula, and Boo Berry on the boxes. But beyond cereals, the characters have become popular in their own right, appearing on other General Mills' products, like Fruit Roll-Ups. They have also been made into all manner of toys—and not just the kind found inside cereal boxes. The licensing of Franken Berry's image has seen him as plush dolls, flavored lip balm, and several figures in the Funko Pop! toy line. The cereal remains popular, and it will always be known for its seemingly magical ability of turning milk pink. Unfortunately, in its earliest days on the supermarket shelves, the milk wasn't the only thing that turned pink.

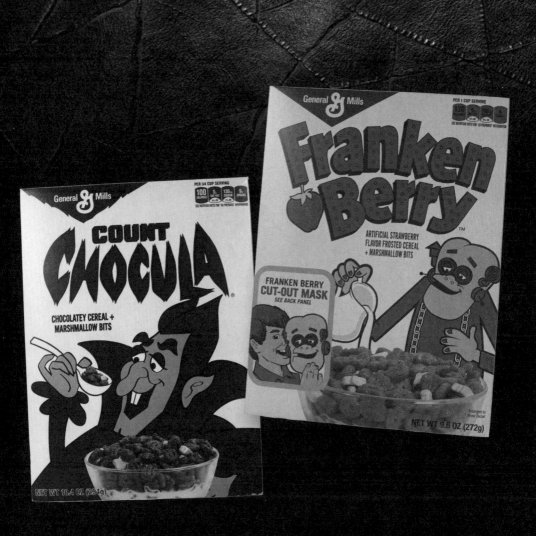

Almost immediately after the cereal was released, there was a notable uptick of children being admitted to emergency rooms across America because their poop had turned pink. Parents who feared bleeding issues were only slightly relieved by the fact that the culprit was really the red dye used in the cereal. Swept up in broader concerns about food dyes in the seventies that ultimately resulted in some changes to the food industry— including Mars removing red M&M's from their color assortment—General Mills ultimately switched dyes. So Franken Berry continues to provide a sweet breakfast treat to this day.

But the condition that became known as "Franken Berry stool" was a low point in the cereal's history, and in Frankenstein's legacy as well.

ABOVE: Monsters are also delicious! Count Chocula and Franken Berry cereals were a hit with hungry kids.

Frankenstein features as a good friend and favorite uncle to Dracula and his daughter in the *Hotel Transylvania* franchise.

franchise. What began in 2012 as an animated comedy film featuring the voice work of Adam Sandler, Selena Gomez, and Kevin James as Frankenstein, or more casually, Frank, has spawned sequel movies, a television series, short films, toys, books, and Halloween costumes. The premise of the films is that Dracula (Sandler) and his daughter Mavis (Gomez) operate a monsters-only hotel, a safe space for the classic creatures of the world to seek refuge from a torch-bearing human population. But when Mavis wants to venture out to that human world to celebrate her 118th birthday, the reclusive monsters quickly realize humans are now much more tolerant of their kind.

Though Frank is not the star of this series, he does play a key supporting role as Dracula's best friend and Mavis's favorite "uncle." He also has his own bride in the character Eunice, played by Fran Drescher, who sports a white stripe in her black bouffant hairstyle. Being a Sony Pictures production, animators had to avoid replicating the trademarked look of the Universal Pictures version of the monster when creating the original model for the character. To do so, they took a little bit of the familiar and adjusted it just enough to avoid duplication. While this version of Frankenstein does have a flattop head, pronounced skull, and scar, his light blue-gray skin tone sidesteps the traditional green coloring that audiences have come to associate with the monster. Counterintuitively, his skin is truer to the appearance of the Universal Pictures Frankenstein who was shot on black-and-white film. Also missing are the bolts in the

neck. That said, this animated Frankenstein has two small ears on the lower part of his head, which almost mimic the placement of the bolts, providing a familiar feeling without replicating the trademarked element.

Although the main plot of the series revolves around Dracula, Mavis, and their family, Frank is a constant throughout the franchise. The affable giant of a creature has the traditional fear of fire and a penchant for traveling by shipping his body parts separately because of a fear of planes and, apparently, trains. Much of Frank's role in the first film of the franchise surrounds his confusion around a previously unknown cousin called Johnnystein, who turns out to be Mavis's new human boyfriend in a hastily created disguise made by Dracula. Initially offended by his best friend for lying about the human in their midst, Frank is one of the first to come around to Johnny, supporting Mavis's new relationship. This leads to the monsters finally reconnecting with humanity to learn that they aren't feared anymore, but admired and cheered on, reaching a level of celebrity status associated with the classic monsters celebrated by real-world audiences, and ushering in a new age of human-monster relations.

The franchise continued to grow strong over a decade after the first film was released. The theatrical sequels, *Hotel Transylvania 2* (2015) and *Hotel Transylvania 3: Summer Vacation* (2018), culminated in the Amazon Prime–exclusive streaming film *Hotel Transylvania: Transformania* in 2022. Although most of the voice cast reunited for the film, Adam Sandler and Kevin James were notably absent. The same is true of the TV series, *Hotel Transylvania: The Series*, that ran from 2017 to 2020, in which the entire voice cast was replaced, which is typical of most movies-turned-TV-series. The franchise also spawned a number of short films with *Goodnight, Mr. Foot* (2012), *Puppy!* (2017), and *Monster Pets* (2021). In June 2024 the Netflix streaming service announced a new series, called *Motel Transylvania*, to be released in 2025.

THE BRIDE REVISITED

For most of its existence, the character of Frankenstein's monster was largely considered a property for boys—but that too has been changing. Sure, there was the bride. But she was always the bride and never the Frankenstein. That's changing too. Now Frankenstein has female personifications that weren't created to be anyone's mate. While it is true that a lot of this gender-bending is a way for corporations to sell girls on a character that is traditionally geared toward boys, it has opened up the horror genre for kids overall. Whether girls *or* boys prefer their Frankenstein as a hulking creature with masculine features or a sharply dressed girl with long, flowing hair, there's finally something for everyone when it comes to the monster for kids.

Monster High's Frankie Stein draws from her love of horror predecessors for her look. The green recalls the Universal monster, and the black-and-white hair is a nod to the Bride.

In scary-but-still-funny programming, there are few more popular examples than Hanna-Barbera's *Scooby-Doo*. First launched in 1969, the franchise featured the famous Great Dane and his teenage human friends touring in their Mystery Machine and encountering all kinds of creatures of the night. In the early cartoons, more often than not the monsters turned out to be humans in disguise. By 1988, though, Scooby, Shaggy, and the gang— including Scrappy-Doo—had encountered their fair share of actual monsters. In the direct-to-video animated film *Scooby-Doo and the Ghoul School*, they not only got to meet the classic characters from the Universal films but they also encountered the monsters' offspring, including one Elsa Frankensteen.

This daughter of the Frankenstein monster received the familiar surname—with one minor teen-centric modification—combined with the given name of the actress who portrayed the title character in *The Bride of Frankenstein*. Over fifty years later, Elsa Lanchester's legacy as Frankenstein's bride proves that the Universal horror franchise runs deep. Elsa Frankensteen wears her black hair teased up, with a bolt of white running through it like the original bride's. Her skin is pale, but she wears green rags as a dress, in honor of what has become the accepted color of the monster's skin. A pair of platform sandals are also a subtle nod to the giant platform boots the creature often

wears. Elsa Frankensteen is not a phantom, and neither are her friends, the daughters of Dracula, the Wolf Man, and the Mummy.

In 2010, more of Frankenstein and his bride's progeny would appear. In the Mattel toy company's Monster High line of toys, books, and animated films and shows, Frankie Stein is more modern and stylish than her eighties cousin, befitting the fashion doll line that she sprang from. This female Frankenstein's mythology is a little vague, depending on the source material. In the animated series, she is the newly created daughter of Frankenstein and his bride. In the *Monster High* books by Lisi Harrison that launched the brand's mythology, she is their granddaughter and the child of *their* children, Viktor and Viveka Stein. No matter the origin, the original monster is called Frankenstein in any iteration of this character. The human Dr. Victor Frankenstein also plays a part in the animated series when Frankie goes back in time to meet her ancestor and the original creator of her line.

Frankie's hair is streaked with black and white, taking that usual shock of white and pumping it up into a more stylish do. Strategically placed scars look more like tattoos on her mint-green skin; the bolts in her neck are a new kind of fashion statement. A pair of platform boots finish off the look for the teen who appears to be fifteen years old, even though she's been around for a little less than that. Mattel's website lists her as 115 days old, noting that some parts are older than others. She possesses a teen's equivalent intelligence and maturity, though she obviously lacks the life experience of her peers: friends with names like Draculaura, Clawdeen Wolf, Lagoona Blue, and, with a name reminiscent of *Young Frankenstein*, Abbey Bominable. A running gag throughout the series is that when Frankie wakes up in the morning, her father greets her with a cheer of "It's alive!" a shout-out to the 1931 film.

Mattel's Monster High has become one of the top-selling lines of fashion dolls in the world, up there with Barbie and the Disney Princesses. The dolls have spun off to inspire more toys, video games, costumes, and bedding. The friends have grown beyond the original Lisi Harrison titles, published as young-adult novels, to generate books for children of all ages. And, of course, the animated series, films, and web series have opened up the mythology even more. Mattel built off the success, adding a similar fashion doll brand with *Ever After High* in 2013, centered on fairy-tale characters. Other companies got in on the act too with Disney launching its own TV movie and brand, *Descendants*, starring the children of their famed villains.

Some may take issue with drawing connections between Mary Shelley's literary work and a line of teen fashion dolls, but it's hard not to. Created almost two hundred years after the novel's inception, the fashion-forward characters represent an aspirational model for today's teens, one where friendship and acceptance is infused into their very

being. It's a far cry from the isolation and loneliness of the original *Frankenstein*, written by a girl who was, herself, a teen at the time. *Monster High* may not reflect the literary origins of the character, but it may be a variation on the story's original theme.

In the years between *Scooby-Doo and the Ghoul School* and *Monster High*, famed film director-producer Tim Burton released *The Nightmare Before Christmas*, a stop-motion animation film about Jack Skellington, the Pumpkin King of Halloween Town. The 1993 movie is filled with creepy characters with a uniquely Burton-esque design, including vampires that share Count Dracula's aesthetic. The movie has a traditional Frankenstein monster, but it appears so briefly it barely counts as a cameo. But that's not the only tie to the monster's myth. Sally, Jack's love interest in the film, is a stitched-together rag doll crafted by the evil Dr. Finkelstein. Allusions to Frankenstein's monster and its bride are obvious in Sally's story, which should be no surprise: the Frankenstein tale has clearly been an inspiration for her creator, Tim Burton.

DOG STAR

Writer-producer-director Tim Burton has made a career of stylistic films that frequently deal in the macabre, but his name might not be the first that comes to mind when considering the Frankenstein legacy. James Whale and Terence Fisher were more directly linked by their remakes of the story and what they both contributed to the mythology. Going through Burton's film résumé, it's clear that Mary Shelley's influence—and the great *Frankenstein* horror films of the past—is a common thread that runs through his work, from *The Nightmare Before Christmas* and another stop-motion feature, *Corpse Bride* (2005), to the movie that truly brought out Burton's unique viewpoint: *Edward Scissorhands*.

The title character in that 1990 film is a Frankenstein-like creation, an artificial man with hands made of scissors. He is an outsider, misunderstood by the so-called normal suburban residents, some of whom react to him in fear while he is merely trying to find love, or a mate. *Edward Scissorhands* embraces Mary Shelley's themes of isolation and discrimination based on appearance. This "monster" does find acceptance when his talents for topiary and hairstyling are revealed, but it is short-lived. His differences are too much for the neighbors, who ultimately shun Edward, sending him into isolation after he is pushed into committing a murderous act.

OPPOSITE: Tim Burton's *Edward Scissorhands* (1990) features Edward, a creation with monstrous hands and a true heart.

Mary Shelley's inspiration—as well as James Whale's— was also evident in a work that came out both before *and* after *Edward Scissorhands*, in one of the most uniquely titled entries in the creature's legacy, a family film called *Frankenweenie*.

The first version of *Frankenweenie* was released as a short film in 1984, when Burton was an employee of Walt Disney Studios. It was his second short film for the studio better known at the time for its more straightforward, kid-friendly content. The first, *Vincent* (1982), was about a boy experimenting on his dog to create a zombie version

The Corpse Bride (2005), another film from Tim Burton, shows how much Mary Shelley's original novel influenced the director.

of the animal—not exactly traditional fairy-tale fare. *Frankenweenie* explores similar themes with a boy named Victor Frankenstein, who uses electricity to reanimate his dog, fittingly named Sparky. The black-and-white, live-action short, with a half-hour running time, parallels Mary Shelley's story and the 1931 film as both a parody and a loving homage. Victor's neighbors fear the reanimated dog, sending it on the run.

When it hides out in the windmill of a local miniature golf course, its human pursuers accidentally set the windmill on fire. Sparky dies in that fire, making sure to save its creator's life first. When the neighbors realize what they've done, they band together to revive the creature with their car batteries. The boy and his reanimated dog live happily ever after, with Sparky finding a potential mate in a poodle with a familiar hairstyle.

The offbeat film marked the end of Burton's initial time at Disney, but it also served as a calling card for the director. Paul Reubens (Pee-wee Herman) saw the short and hired Burton to helm *Pee-wee's Big Adventure* (1985). But Reubens was one of the few who were able to view it: Disney found the short too scary for young audiences and didn't know what to do with it at the time. They shelved the film in the US, though it was seen in England. As Burton's star rose over the next few decades, so did Disney's interest in the archived project. Walt Disney Home Video finally released *Frankenweenie* to the public in 1992, and later paired it with *Vincent* as an extra feature on DVD and Blu-ray releases of *The Nightmare Before Christmas*.

Nearly thirty years after the short first came out, Disney reteamed with Burton to update the story as a full-length stop-motion animation feature, again presented in black-and-white. The story expands on the original, with new characters like Victor's neighbor Elsa Van Helsing and misfit friend Edgar "E" Gore in a plot that involves other classmates interested in Victor's scientific achievement. As the director told *Entertainment Weekly* in 2012, themes of isolation found in the mythology are ever present in childhood, particularly his own. "I remember the school politics," he said, "and not only how weird you felt as a kid, but how weird everybody else was too. It was easy to link those memories to old horror movies. I mean, there was a kid back in school that would remind me of Boris Karloff. And there was a weird girl." In this particular story, he tied those familiar characters together through the reanimation of a dead dog.

INSPIRED BY

Frankenstein is for grown-ups too, and countless writers, directors, producers, and behind-the-scenes personnel have found inspiration in the story. Long before he directed his 2025 *Frankenstein* film, Guillermo del Toro wrote about that inspiration as much when the writer-director provided the introduction to the 2017 edition of *The New Annotated Frankenstein*. Boris Karloff's portrayal first introduced him to the monster

OPPOSITE: Persephone, from *Frankenweenie* (2012), sports the iconic Bride hair.

and prompted him to seek out the novel years later. He connected with the material in much the same way many young would-be artists do, finding a kinship in the monster's outsider status. As del Toro cites in his introduction, it is a universal theme that inspires his work because "history is written by the victors, but art is mostly chronicled by the disfranchised." That inspiration yields critically acclaimed award-winning films and mass-market rides alike, both large and small scale.

It also inspires movies in which children and teens, motivated by their love of these classic characters, go on their own new adventures in a world where *Frankenstein* already exists. *The Monster Squad* (1987) blends childhood with monsterhood in a lovingly crafted homage to the classic film characters. A group of preteens in a club devoted to the famous monsters find themselves in their own mystical plot that pits them against a group of real supernatural beings. Led by Count Dracula, these villains match the styling of the Universal monsters, with makeup designs by a team that included famed special-effects makeup artist Stan Winston. These monsters, however, have loftier goals than their predecessors: they want to destroy the world. Frankenstein's monster plays a part in the scheme, but much like its earlier incarnations, it is not the villain of the tale. The creature empathizes with the young human heroes and forms a bond with the little sister of one of the kids, mirroring its past relationships with children that ended in tragedy. In this tale, the monster becomes an ally, helping the children thwart Dracula and his minions, before willingly joining the creatures in a portal to another world, knowing that is where it truly belongs.

Frankenstein and Me (1996) is a film on a somewhat smaller scale that follows a twelve-year-old boy named Earl who vividly dreams of the monsters he grew up watching and reading about in comic books. After the death of his father, Earl becomes obsessed with reviving a "Frankenstein monster" that was accidentally left behind by a traveling carnival. For most of the movie, Earl doesn't revive the monster. It doesn't wake and lumber around on an accidental killing spree. This isn't a horror story or a science-fiction tale. The solace that Earl finds with the creature has nothing to do with it coming to life. It is a connection between Earl and what the creature inspires. Although at the end, the film hints at Earl's success. The creature will rise once again, as it always does.

OPPOSITE: A movie poster for *The Monster Squad*. The film mixes childhood with an homage to classic horror characters.

POP CULTURE ICON

6

Once upon a time, fans gathered together in small hotel ballrooms to celebrate a shared interest in some form of entertainment, usually genre related. That still happens every weekend across the globe. But these smaller celebrations have been joined by grandiose operations featuring celebrities, media, and huge money-making opportunities for vendors and anyone looking to profit from the party theme. The subjects of these celebrations range from science fiction and horror to romance and even adult entertainment. Audiences come to socialize, rub elbows with celebrities, and gain exclusive access to previews or behind-the-scenes news. And they come to buy—posters, toys, gifts, and collectibles bearing the likenesses of the things they love.

Science-fiction conventions have been around since the days when *Frankenstein* lurched its way across the big screen for Universal Studios. They started long before *Star Trek* popularized the convention circuit—long before *Star Trek* even started airing. The first World Science Convention

OPPOSITE: Trick-or-treaters dressed as Frankenstein and Vampira in 1979 Brooklyn.

was held in conjunction with the New York World's Fair in 1939. The two hundred attendees included Forrest J. Ackerman, who would go on to create *Famous Monsters of Filmland*. Ackerman himself became a regular and respected guest on the convention circuit, attending these events right up until his death in 2008. Sci-fi conventions embraced horror too. But the genre eventually spun off into its own convention circuit celebrating the monsters and the creative forces behind them. From the very first horror convention, Frankenstein was a big star, particularly in the dealer's room.

Every convention has one. It's where the real money is made. The dealer's room is effectively the convention gift shop, but it's usually way bigger than any store one would find in a museum. Tables and tables of companies and collectors line a room with sellers pitching anything and everything they can in conjunction with the convention's theme. Sometimes, they're high-end licensed products that have the full blessing of the original owners. Other times, they could be cheaply produced knockoffs that are beloved collectibles specifically because of their unofficial associations. Often, they fall somewhere in between.

Frankenstein merchandise comes in many forms and has been sold far beyond the traveling road shows that are horror conventions. The Frankenstein community doesn't just consist of people who would make the trek to a convention. It includes people who don't even realize they become part of a community when they purchase a silly paper decoration for their door, even if it stays up for only a month at Halloween and then ends up in the garage for the rest of the year. Unlike fans of *Star Wars*, *Star Trek*, or *Lord of the Rings*, the Frankenstein fan community is full of people who have never read the book or ever viewed one of the movies.

The character of Frankenstein the monster can be found in toy stores, bookstores, party stores, and online retailers—basically anyplace products are sold. The monster has many faces. Sometimes it's the familiar one from the movie featured on collectibles; other faces have no ties to the famous monster of film. New literature and pulp fiction have spun out of Mary Shelley's original work. Frankenstein has even entered the world of video gaming with futuristic versions of the visage. No matter the look, no matter the medium, Frankenstein is a major powerhouse in merchandising.

A FACE FOR SUCCESS

When it comes to Frankenstein merchandise, there are really two kinds: the generic green monster who has any number of cartoonish representations, or the character with Boris Karloff's or Glenn Strange's expressive face beneath the makeup. The first may be bought by anyone of any age, but the second usually attracts the film buff, or,

Life-size models of Regan from *The Exorcist* and Frankenstein's monster terrorize audiences at the Scare LA Horror Convention in August 2006.

specifically, the Universal horror film fan. Both images have ties to the 1931 *Frankenstein* film, and therein lies the problem.

When James Whale went behind the lens to film his *Frankenstein* masterpiece, Mary Shelley's original work had already entered the public domain. Anyone who wanted could make a *Frankenstein* film, book, or anything else that came to mind. But what Jack Pierce created with his makeup design for the film revolutionized the monster. Whereas Shelley barely described her creation in the book, the Universal film projected its image onto a giant movie screen for what would become its largest viewing audience since the character's inception. When Universal trademarked their monster's look, they didn't claim ownership of Shelley's work. They just took the monster.

What specifically the movie studio trademarked in Pierce's makeup design can get into both vague and complicated legal terms. It is generally accepted among *Frankenstein* fandom that the studio claims to own the following five elements that, when combined in a single image, would result in infringement: green skin, flattop head, scar on the forehead, bolts on the neck, and protruding forehead. Any one or

LEGO Frankenstein is not so far from the pieced-together monster in Shelley's tale.

two elements may not raise the interest of the studio's legal team. But putting all five together runs a risk that persists until the trademark eventually runs out.

One key element of the look that the studio does not officially own outright is the actor beneath that makeup. Karloff's image clearly shines through in both his performance and his facial expressions. As such, the actor would receive royalties anytime his films aired on television, anytime Universal partnered with companies to make merchandise, or for any other number of reasons. Decades after the actor's death, Karloff's daughter, Sara, joined with the children of the other Universal classic monster movie stars to ensure that the actors' estates continued to control the use of their parents' likenesses in and out of makeup. The case was settled in a confidential decision. Sara Karloff has commented at the Official Boris Karloff Web Site to confirm that she will "retain all rights to the likeness of [her] father, Boris Karloff. This is most signifcant [sic] in that it allows [her] to maintain an appropriate standard of good taste when [her] father's likeness is used. That has always been a primary concern and objective of the family."

Just how has that likeness been used? In so many different ways.

Boris Karloff's character from the Whale movies has become its own offshoot merchandise program when it comes to Frankenstein products specifically tied to the film. The merchandising exploded soon after the original movies were on *Shock Theater*

in the late fifties. Frankenstein toys were not only popular, but they played a small part in revolutionizing the merchandizing industry.

The Aurora Plastics Corporation had made a name for itself in the toy and hobby market years before the 1931 *Frankenstein* film ever appeared on television. The company was initially known for kits that gave kids and adult model makers the opportunity to build small-scale replicas of their favorite aircraft and cars. Figure kits followed, showcasing knights and animals and all manner of personalities available in the public domain. That changed in 1961 when the company entered into a contract with Universal Studios to make their first figure based on a horror character. They chose to launch with Frankenstein.

Model maker Jack Lemon sculpted the kit based on a design from an existing Frankenstein wind-up toy sold by the Marx toy company. Over two dozen pieces fit together to form the body of the monster, which appeared to shuffle forward on a base that carried a tombstone bearing the name "Frankenstein." *And* it glowed in the dark! Of course, the real fun came from painting the model, with most makers choosing the familiar olive green that had become associated with the monster and reflected on the box cover. There was no doctor in the kit. The Frankenstein in question was most assuredly the monster. The box carried the image of Glenn Strange's Frankenstein on the front, but the product was clearly intended to evoke memories of the first *Frankenstein* film.

The Frankenstein kit was one of the earliest licensed models on the market, and it was an immediate hit upon its release in 1962. It was so popular, in fact, that *Mad* magazine lampooned the kit in 1964 when it featured a Boris Karloff-esque Frankenstein monster on its cover putting together a model kit of the magazine's mascot, Alfred E. Neuman. Soon after the Frankenstein kit was released, Aurora tapped into the rest of the Universal horror line with Dracula and the Wolf Man to follow in time for Christmas. The next year saw even more monsters and more success as the company moved beyond horror and on to superheroes. With a license covering DC Comics characters, they released Superman, Batman, Robin, and even Wonder Woman battling an octopus in 1964.

The year after Wonder Woman's release, Aurora added the Bride of Frankenstein to their line, but she resulted in disappointing sales. This was a time when girls weren't supposed to be interested in horror characters, and boys weren't interested in so-called girl toys—and a model kit that featured a female character was enough to earn it the dreaded designation. Although the Bride kits weren't popular at the time, the scarcity of the original models makes them very sought after today. In more recent decades, Moebius Models reached back into Aurora's archives and reissued many of their most

Big, Green, and Scary(ish)

Mary Shelley's original description for Frankenstein's monster stated that it had yellow skin that "scarcely covered the work of muscles and arteries beneath." But, like an eco-warrior of the twenty-first century, somewhere along the way the monster went green. As with Igor, it's difficult to pinpoint the exact moment that green coloring became an established part of the Frankenstein mythology. But it's likely tied back to the Universal films that established the universal look for the creature.

As noted earlier, the first time Frankenstein's monster was seen outside of the pages of a book was in 1823 with the theatrical production of *Presumption; or, The Fate of Frankenstein*. The actor playing the part wore light-blue makeup, establishing a skin coloring that carried through other stage productions in the character's first century of existence. When the monster transitioned to screen, it initially did so in black-and-white films, where color was in the eye of the beholder. Jack Pierce's makeup application on Boris Karloff had a blue-green tint so it would appear deathly pale on screen. The motion-picture marketing team took it from there. Dr. Frankenstein's creation is yellow on the movie poster for the original *Frankenstein* in 1931 and in some of the advertising for the sequels, but it is also green on one sheet for *The Bride of Frankenstein* and *Son of Frankenstein*. Some behind-the-scenes footage of Boris Karloff's performance in *Son of Frankenstein* was also released in color to market the film, revealing the makeup with that light-green tint.

The green coloring of the monster was fully set by the sixties, with the release of the Aurora model showing the creature in green on the box cover. Although the Hammer films had largely flesh-colored creatures, *The Munsters* took the green coloring and ran with it. The TV series aired in black-and-white, but all Herman Munster products depicted the character as green. This was cemented in the color film release that followed the TV series, *Munsters, Go Home!* Today, versions of the monster with different skin coloring still exist— particularly in film—but the more familiar look largely associated with the creature people know as Frankenstein is overwhelmingly green.

popular kits, including both Frankenstein and its bride. This time, they both found considerable success.

The Universal Monsters have become a licensing brand of their own like *Star Wars*, *Star Trek*, DC, and Marvel characters. At the turn of the millennium, there was something of a classic monster revival, with more and more companies making finely detailed replicas. What was once a cheap molded plastic toy was now a high-end sculpted work of art, and Universal Monsters have been at the forefront of that movement with their core fan base of devoted collectors. Karloff's Frankenstein is always featured in the studio's line. Its likeness has been captured by companies that trade in toy and sculpted collectors' items like Sideshow Collectibles, Mezco Toyz, Diamond Select Toys, and others. The Universal Monsters can be found in everything from action figures to dolls to decals appearing on car windows. The monsters even had their own line of stamps released in 1997 from the United States Postal Service. But Universal hasn't completely cornered the market on the monster.

The Frankenstein monster continues to exist outside of the Universal image, produced by companies both large and small. Funko Pop! is one of the major players in pop-culture memorabilia that has expanded on the look of the monster. By 2018, the company was promoting a dozen Frankenstein products on their website. Though many were tied to the film franchise, they expanded beyond to include a generic Frankenstein's monster in a variety of fun styles and colors ranging from gray to glittery blue and green. The line also includes other licensed Frankensteins, from Peter Boyle's embodiment in *Young Frankenstein* to the lesser-known Frankenstein Jr. robot from the Hanna-Barbera cartoon.

Hot Wheels is another brand that has embraced the monster in its various forms, with Mattel producing versions of their cars based on the Universal monster and its bride, and even a Franken Berry cereal–themed car. The toy company also famously produced a scale replica of the Dragula vehicle, the Munsters' family car. LEGO has gotten into the act as well, with several minifigures in the spirit of the creature released over the years. Their names range from direct callouts like "Frankenstein's Monster" to more vague monikers like "The Monster" and "Crazy Scientist's Monster." True to LEGO form, the character has seen even more unique representations as "Monster Butler" and "Monster Rocker."

Major manufacturers aren't the only ones tapping into the Frankenstein toy market. The monster has been embodied in everything from cheaply produced novelty items to pieces of fine art. Halloween continues to be an especially popular time for monster products, of course, with Frankenstein costumes, giant inflatable yard characters, and

even candy bowls where the sweet treats fill the creature's skull. With so many different iterations of the character, it's hard to estimate how much money Shelley's creation—or creatures *inspired by* her monster—have made over the centuries. But there is little doubt that the character is banking a lot of green.

NEW MEDIA AND OLD

Atari set the standard for the video game era of the seventies and eighties, bursting onto the scene in 1972 with *Pong*. The simple table tennis–like game had two players—or a player versus the computer—controlling paddles on either side of the screen, sending a square "ball" back and forth. A ridiculously basic game by today's standards, *Pong* effectively created a new industry of arcade gaming. Atari quickly brought those games into the home, launching an in-home computer gaming system in 1977 with the ability to load countless cartridges of games featuring eight-bit adventures. The home-gaming market exploded with titles consisting of original adventures to those tied to movies and even novels, like *The Hobbit*.

In 1983, the company Data Age expanded on literary content when they released a game for the Atari system called *Frankenstein's Monster*. The player was responsible for stopping Dr. Frankenstein from bringing his monster to life, where it could then rampage out of the castle.

A more story-based text adventure game for Commodore 64 had players taking on the roles of both Frankenstein and the monster in a plot more closely tied to Shelley's original novel. The game was simply titled *Frankenstein* (1987). Though the monster had a starring role, a much larger video game release would soon eclipse this smaller entry in the Frankenstein catalog. Konami's *Castlevania* (1986, released in North America in 1987) was an action-adventure game that saw players negotiate their way through Count Dracula's castle, where they encountered Frankenstein's monster among other dangerous threats. Although the monster was only a bit player in the adventure, the massively popular game spawned a series that continues to this day.

Frankenstein truly came into its own as a video game star in the nineties, with *Dr. Franken* leading the way in 1992. First released on the Game Boy handheld game console, the game follows the adventure of Franky, a monster occupied with collecting the body parts of its potential bride, a girlfriend named Bitsy. *Dr. Franken* was so successful that it earned a sequel in 1997. But Frankenstein's monster did not lie dormant between these two releases.

In 1994, Sony Imagesoft released *Mary Shelley's Frankenstein,* which was tied to the film of the same name by Kenneth Branagh. And in 1995, the former Dr. Frank-N-

Furter, Tim Curry, got in on the Frankenstein gaming craze by providing the voice of the doctor in *Frankenstein: Through the Eyes of the Monster*. This is one of the few times that the doctor is featured in a game, although the title clearly tells the audience who's the real star of the story. Like so many incarnations of the legend, video games generally embrace Frankenstein as the monster's name.

Comic books are an outgrowth of traditional prose publishing that in some ways bridge the pop culture gap between video games and books. And like all other forms of media, Frankenstein and his monster have had made their presence known on the comic page through countless reinterpretations and reinventions. The monster has served as inspiration for major

This 1960s *Classics Illustrated* edition of *Frankenstein* includes illustrated comic book adaptations of Shelley's work.

characters like Marvel's the Hulk and DC Comics' Cyborg. It has also been a character on its own for both of those publishing houses, as well as numerous independent publishers over the many decades since the comic book industry first formed.

In many cases, these graphic takes on the story are retellings of Shelley's tale. Some of them remain true to the original, while others are often flights of horror-fueled fantasy. Prize Comics managed both in 1940 with their comics titled *Frankenstein* and later *New Adventures of Frankenstein*. What started out as a straight horror comic evolved into the monster as a modern-day war hero and ultimately a comedic character

"A MONSTER MOVIE FOR THE THINKING PERSON"

—David Sheehan, KNBC-TV, LOS ANGELES

From the
grand master of horror...

Classic terror
is now
state-of-the-art shock.

JOHN HURT · RAUL JULIA

ROGER CORMAN'S

FRANKENSTEIN
UNBOUND

A MOUNT COMPANY PRODUCTION
JOHN HURT · RAUL JULIA
ROGER CORMAN'S FRANKENSTEIN UNBOUND BRIDGET FONDA JASON PATRIC MICHAEL HUTCHENCE as Shelley
NICK BRIMBLE CARL DAVIS JAY CASSIDY BRIAN W. ALDISS ROGER CORMAN F.X. FEENEY
ROGER CORMAN, THOM MOUNT, KOBI JAEGER ROGER CORMAN

R Color by DELUXE

CBS
FOX

in works spun off from cartoonist Dick Briefer's work. Similarly, Dell Comics released one of the more unique blends of myth and heroism in 1964.

More recently, Boom! Studios updated the tale in a story that provides commentary on race relations in present-day America. *Destroyer* was a six-issue limited series, released in 2017, by Victor LaValle that tied directly to Mary Shelley's novel, with the modern "mad scientist" portrayed as a woman who descends from the line of Victor Frankenstein's brother, Edward, the sole surviving member of the family. In this take on the tale, Dr. Jo Baker brings her son back to life after the young Black boy is killed by police. Her actions start out as an act of grief, but her motivation transforms into a desire for revenge. The original Frankenstein's monster also plays a role in the story as it still exists in this time, living in self-exile in Antarctica. Dr. Baker uses modern technology to revive her son, highlighting ethics questions that science has been wrestling with throughout the two-hundred-year history of the work.

Frankenstein; or, The Modern Prometheus entered the public domain long before the 1931 film retold the story, and although the makeup effects used in that movie were trademarked, it didn't change the fact that the story was out there for anyone to tell. And they have told it. Beyond the games and comic books, *Frankenstein* novels, short stories, sequels, and prequels have covered a wealth of territory inspired by or merely hinted at by Shelley. Along with direct adaptations, the creature has also become an allegory for a multitude of issues that aren't even tied to the original work. To list them all would be a separate book of its own. Suffice it to say, *Frankenstein* has appeared in prose far more often than it's appeared on film—and that's saying a lot.

Pulp-horror magazines and dime-store novels from the early- to mid-twentieth century were the perfect venues to take up the mythology a hundred years after the original publication. These cheaply produced stories served as entry-level works for the monster. Most did not share the same literary depth of the original, but they became their own genre, inspiring readers in huge numbers and showcasing writers who became major talents in their own right. Many of these readers also grew up to be writers, perpetuating the genre and giving it more credibility in a world that tends to dismiss mass-market entertainment. One of the novels more celebrated for its literary value is Brian Aldiss's 1973 work, *Frankenstein Unbound*, which tends to stand out among the pack in spite of the lackluster film made from the book.

OPPOSITE: The movie poster for the 1990 film adaptation of *Frankenstein Unbound* (1973), a standout literary novel that grew out of *Frankenstein* fan fiction.

Of the many different iterations of *Frankenstein* in print, two novel series published decades apart have become key players in the mythology. The first, a 1957 French series—predominantly authored by screenwriter Jean-Claude Carrière, writing under the name Benoît Becker—served as sequels to Shelley's work. The six-book series began with *La tour de Frankenstein* (The Tower of Frankenstein), which follows the monster on its murderous rampage across Europe. A more modern horror master, Dean Koontz, updated Shelley's tale in 2004 with *Prodigal Son*, the first in a series starring Victor Helios, a modern Dr. Frankenstein. In the books, Victor serves as the villain, continuing to make his monstrous creations while the police and his first "Frankenstein" work to stop him. The books proved so popular that Dynamite Entertainment adapted the series into comic-book form.

These two series represent the different ends of the spectrum of the Frankenstein legend. At times, the story is about a madman obsessed with pushing the limits of science in pursuit of godlike abilities, while other times he is the well-intentioned genius horrified by his own actions. Then there are the tales in which the scientist doesn't even play a part, and the monster *is* Frankenstein, a murdering villain or a misunderstood victim. The story can take place in the past or the future, anywhere across the globe or in the far reaches of space. The pliability of Shelley's creation has proven endless inspiration for visionaries who took the story and made it their own, and continue to build off the core concept. Frankenstein is one of those rare creations that has lived on far beyond its death and resurrection.

A Graveyard Smash

One of the most unique retellings of *Frankenstein* was released in 1962 in the form of a song by Bobby "Boris" Pickett. The "Monster Mash" has become the de facto Halloween song, and arguably the most popular holiday tune not tied to Christmas. It's rolled out every October and, though the name Frankenstein is not mentioned once in the ditty, it is indelibly tied to the legend.

The opening lines of the song introduce a mad scientist narrator who is working on a project straight out of Mary Shelley's mind (and the accepted film history of the character). But when this monster rises, it does not terrorize the local village. Instead, it performs a new dance move, a monstrous version of the Mashed Potato. The song is a parody of "Mashed Potato Time," which was about a dance move akin to squishing a bug under the toe of one's shoe. The move associated with the "Monster Mash" has evolved to become a version of the Mashed Potato, but with arms held straight out in front of the dancer in the accepted Frankenstein pose.

The lyrics tap into the Frankenstein mythology and the accepted myths of other classic creatures, in a creative blending of stories. The scientist has his laboratory in a castle and uses electrodes in his work. Dracula and the Wolf Man appear, with the former lamenting the faded dance craze from his own homeland of Transylvania. Even Igor shows up wailing on chains in what was likely one of the more significant mentions tying him to the mad scientist.

Not only has the "Monster Mash" proved a popular Halloween-time song, it was also the basis of a 1995 film, *Monster Mash: The Movie*, which features many of the tropes that have become associated with the Frankenstein legend. Sadly, this version of the story didn't really make its mark in the mythology of the character, or even come close to being as popular as the song.

In the song, Pickett does an impression of Boris Karloff—*the* Frankenstein reference.

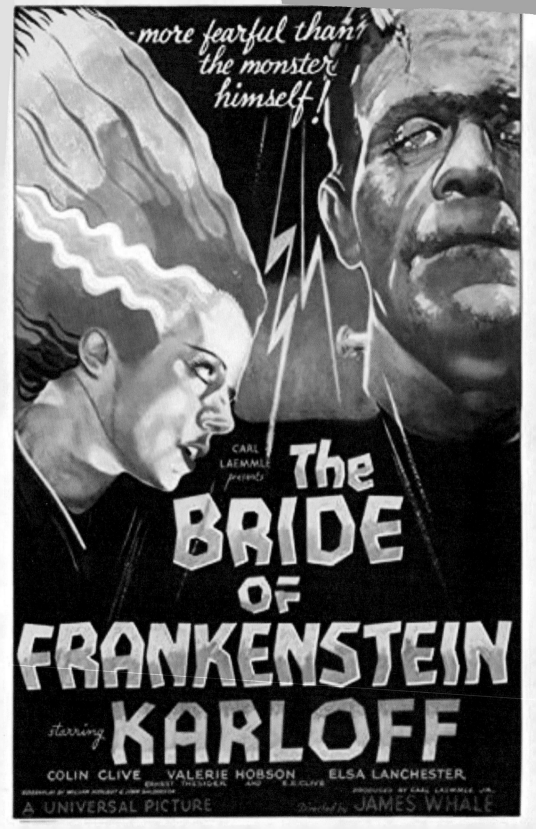

AFTERWORD

"He was soon borne away by the waves and lost in darkness and distance."

The final line of Mary Shelley's masterpiece could not be further from the truth, for Frankenstein's monster did not disappear into that good night. It continued to make its presence known for two centuries in the printed form, on stage, in film and television, and even with adorable little plush dolls. It gained the friends that it had longed for in its original life. It also took on new and different forms completely unrelated to the doctor and the writer who created it. Today, Frankenstein no longer hides in shadows, only revealed by flashes of lightning.

Universal Studios may not have created Frankenstein, but they continue to market the monster they made famous. Their Dark Universe is the working name for a series of films planned to reboot their famous monsters into a shared mythology like Disney successfully produced with their Marvel films. Universal's films have yet to meet with critical or box office success, but the concept isn't dead. It lives on like those original Universal monsters.

Beyond licensing the images of Boris Karloff and Glenn Strange under Jack Pierce's trademarked design, the studio continues to invest in the creature. Look no further than the Universal Studios theme park to reveal the impact the creature has had on the studio. Whether parking in the Frankenstein lot at Universal

ABOVE: Frankenstein hoists up Abbott and Costello in a promotional picture for *Abbott and Costello Meet Frankenstein*.

OPPOSITE: Poster art for *The Bride of Frankenstein* (1935).

Studios Hollywood or visiting the new Dark Universe in the Universal Epic Universe at the Florida theme park, Frankenstein is as popular a draw as the Minions, the *Jurassic Park* ride, or the house from *Psycho*. But Universal isn't the only content creator with interest in the monster. It continues to exist in film, television, video games, and, of course, books.

Over two hundred years after the publication of *Frankenstein; or, The Modern Prometheus,* Dr. Frankenstein, his monster, and the world introduced in the novel is fully in the public domain, and the public has fully embraced that universe. In entertainment, it lives on with all the major studios and streaming services, not just Universal Pictures. With the advent of AI, automated vehicles, and other technological advancements of the twenty-first century, contemporary and futuristic reinterpretations of Frankenstein's monster are guaranteed to continue through the next century and beyond. It is unlikely that the author credited with creating the genre of science fiction could ever have imagined her impact on the world, or that the life she created would take on many different lives of its own.

Another monster: The creature in *The Evil of Frankenstein* (1964).

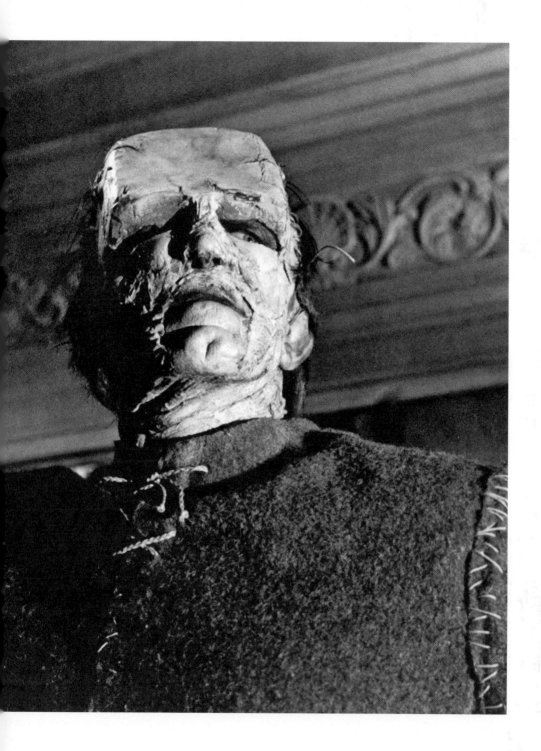

It's The Silliest Party of the Year...
and you're all invited!

SEE FRANKENSTIEN— the ghoul who never loses his cool!

SEE DRACULA— the world's original Batman!

SEE THE CREATURE— the fish you'd like to forget!

SEE THE WEREWOLF— that sly old dog whose bite is worse than his bark!

SEE DR. JEKYLL AND MR. HYDE— and get two fiends for the price of one!

SEE THE MUMMY— 135 feet of slithering, slinking bandage!

SEE THE HUNCHBACK OF NOTRE DAME— college football's "secret weapon"!

SEE THE INVISIBLE MAN—and learn what he has up his sleeves!

A Rankin-Bass Production

Starring the talents of **BORIS KARLOFF** in **MAD MONSTER PARTY**

with the talents of Ethel Ennis · Gale Garnett

SAT.-SUN. Matinee Only!

and also starring the talents of **PHYLLIS DILLER**

Screenplay by Len Korobkin and Harvey Kurtzman · Produced by Arthur Rankin, Jr.

Directed by Jules Bass · Music and Lyrics by Maury Laws and Jules Bass

In _____ and **COLOR** · Prints by Pathe · A Videocraft International Ltd. Production · An Embassy Pictures Release

BIBLIOGRAPHY

Ackerman, Forrest J., ed. *Famous Monsters of Filmland*. Issue #56. Warren Publishing, 1969.

"Adam." Dark Shadows Wiki. October 31, 2017. Accessed January 12, 2018. http://darkshadows.wikia.com/wiki/Adam.

Alexander, Chris. "In Praise of 1973's *Frankenstein: The True Story*." Comingsoon.net. August 8, 2017. Accessed January 11, 2018. http://www.comingsoon.net/horror/features/877021-in-praise-of-1973s-frankenstein-the-true-story.

Allen, Steve, and Robert J. Thompson. "Television in the United States." *Encyclopedia Britannica*. October 18, 2017. Accessed January 6, 2018. https://www.britannica.com/art/television-in-the-United-States.

Aniftos, Rania. "JC Chasez Hopes His 'Frankenstein' Inspired Concept Album Connects People to 'Humanity'." *Billboard*. September 9, 2024. Accessed October 5, 2024. https://www.billboard.com/music/music-news/jc-chasez-interview-frankenstein-inspired-concept-album-playing-with-fire-1235769445/.

Baxter, Joseph. "A Quick Guide to the 15 Major Storylines of *Dark Shadows*." SYFY Wire. October 22, 2016. Accessed January 12, 2018. http://www.syfy.com/syfywire/quick guide-15-major-storylines-dark-shadows.

Breznican, Anthony. "*Destroyer* Comic Book Fuses Black Lives Matter with *Frankenstein*." *Entertainment Weekly* (ew.com). February 13, 2017. Accessed: February 7, 2018. http://ew.com/books/2017/02/13/destroyer comic-black-lives-matter-frankenstein/.

Burton, Nige. "Aurora Monster Models—Turning Every Boy's Dream into a Nightmare!" Classic Monsters. Accessed February 4, 2018. http://www.classic-monsters.com/aurora-monster-models/.

OPPOSITE: *Mad Monster Party* (1967) featured monsters and Phyllis Diller in a stop-motion party held by Baron Boris von Frankenstein.

Burton, Nige. *The Classic Movie Monsters Collection: Frankenstein 1931*. Stripey Media Ltd., 2015.

Burton, Nige, and Jamie Jones. *The Classic Movie Monsters Collection: Bride of Frankenstein 1935*. Stripey Media Ltd., 2016.

Brooks, Mel, with Rebecca Keegan. *Young Frankenstein: The Story of the Making of the Film*. Black Dog & Leventhal Publishers, 2016.

Cremer, Robert. *Lugosi: The Man Behind the Cape*. Henry Regnery Company, 1976.

"Franken Berry." Mr. Breakfast. 2009. Accessed: January 22, 2018. https://www.mrbreakfast.com/cereal_detail.asp?id=139.

"Frankie Stein." Monster High. Accessed January 27, 2018. http://play.monsterhigh.com/en-us/characters/frankie-stein.

"Godwin's First Meeting with Mary Wollstonecraft." *Shelley's Ghost: Reshaping the Image of a Literary Family*. Accessed February 25, 2018. http://shelleysghost.bodleian.ox.ac.uk/godwin-meets-mary-wollstonecraft?item=4.

"Guillermo del Toro: 5 Movies That Made Me the Filmmaker I Am." A.Frame: The Academy's Guide to Movies. Accessed September 21, 2024. https://aframe.oscars.org/what-to-watch/post/guillermo-del-toro-5-movies-that-made-me-the-filmmaker-i-am.

Hitchcock, Susan Tyler. *Frankenstein: A Cultural History*. W.W. Norton & Company, 2007.

"*I, Frankenstein*." Rotten Tomatoes. Accessed January 9, 2018. https://www.rottentomatoes.com/m/i_frankenstein.

"IT'S ALIVE! Frankenstein's Monster for Atari 2600." Retro Game SuperHyper. October 31, 2017. Accessed February 5, 2018. https://retrogamesuperhyper.wordpress.com/2017/10/31/its-alive-frankensteins-monster-for-atari-2600/.

Jensen, Paul M. *The Men Who Made the Monsters*. Twayne Publishers, 1996.

Karloff, Sara. "Commercial Licensing/Settlement Agreement." The Official Boris Karloff Web Site. Accessed January 11, 2018. http://www.karloff.com/?page_id=64.

Koch, Drew. "Will *The Frankenstein Chronicles* Return for a Season 3? The Show Has a Good Shot for Renewal." *Bustle*. February 2018. Accessed March 3, 2018. https://www.bustle.com/p/will-the-frankenstein-chronicles-return-for-season-3-the-show-has-a-good-shot-at-renewal-8251171.

Lang, Cady. "Poor Things and the Profoundly Feminist Origins of Frankenstein." *Time*. December 13, 2023. Accessed September 7, 2024. https://time.com/6344025/poor-things-frankenstein-mary-shelley-feminist/.

Lindsay, Cynthia. *Dear Boris: The Life of William Henry Pratt a.k.a. Boris Karloff*. Alfred A. Knopf, 1975.

"Maggie Gyllenhaal Reveals First Look at Christian Bale as Frankenstein in 'The Bride!'." A.Frame: The Academy's Guide to Movies. April 4, 2024. Accessed September 21, 2024. https://aframe.oscars.org/news/post/the-bride-first-look-christian-bale-jessie-buckley.

Montillo, Roseanne. *The Lady and Her Monsters: A Tale of Dissections, Real-Life Dr. Frankensteins, and the Creation of Mary Shelley's Masterpiece*. William Morrow, 2013.

Moore, Casey. "'Wednesday' Season 2 Casting Three New Season Regulars." What's on Netflix. December 8, 2023. Accessed October 5, 2024. https://www.whats-on-netflix.com/news/wednesday-season-2-casting-three-new-season-regulars/-has-12-new-cast-members-as-production-gets-underway/.

Moore, Casey. "'Wednesday' Season 2 Will Have 12 New Cast Members as Production Gets Underway." What's on Netflix. May 7, 2024. Accessed October 5, 2024. https://www.whats-on-netflix.com/news/wednesday-season-2-has-12-new-cast-members-as-production-gets-underway/.

Murray, E. B. "Changes in the 1823 Edition of *Frankenstein; or, The Modern Prometheus: The Pennsylvania Electronic Edition*." Edited by Stuart Curran. http://knarf.english.upenn.edu/Articles/murray.html.

Neibaur, James L. *The Monster Movies of Universal Studios*. Rowman & Littlefield, 2017.

Nixon, Rob. "Pop Culture 101: *Bride of Frankenstein*." TCM: Turner Classic Movies. Accessed December 26, 2017. http://www.tcm.com/this-month/article/615488%7C0/Pop-Culture-Bride-of-Frankenstein.html.

Open Syllabus Explorer. Accessed February 1, 2018. http://explorer.opensyllabusproject.org.

Peake, Richard Brinsley. *Presumption; or, The Fate of Frankenstein*. Edited by Stephen C. Behrendt. Romantic Circles, 2001. Accessed March 1, 2018. http://www.rc.umd.edu/editions/peake/index.html.

"*The Rocky Horror Picture Show*." Rotten Tomatoes. Accessed January 15, 2018. https://www.rottentomatoes.com/m/rocky_horror_picture_show.

Shelley, Mary. *Frankenstein: The 1818 Text, Contexts, Criticism*. 2nd ed. Edited by J. Paul Hunter. W.W. Norton & Company, 2012.

Shelley, Mary. *The New Annotated Frankenstein*. Edited by Leslie S. Klinger. Liveright Publishing Corporation, 2017.

Sklar, Robert, and David A. Cook. "History of the Motion Picture." *Encyclopedia Britannica*. November 10, 2017. Accessed December 20, 2017. https://www.britannica.com/art/history-of-the-motion-picture.

Smith, K. Annabelle. "Franken Berry, the Beloved Halloween Cereal, Was Once Medically Found to Cause Pink Poop." *Smithsonian*. October 30, 2013. Accessed January 22, 2018. https://www.smithsonianmag.com/arts-culture/franken-berry-the-beloved-halloween-cereal-was-once-medically-found-to-cause-pink-poop-7114570/.

Trendacosta, Katharine. "This Year Will Bring Not One, but Two Frankensteins." io9. January 22, 2015. Accessed January 15, 2018. https://io9.gizmodo.com/this-year-will-bring-not-one-but-two-frankenstein-base-1681066230.

Wiener, Gary, ed. *Bioetheics in Mary Shelley's Frankenstein*. Greenhaven Press, 2011.

Wood, Bret. "The Films of Thomas Edison." TCM: Turner Classic Movies. Accessed December 20, 2017. http://www.tcm. com/this-month/article/345136%7C0/The-Films-of-Thomas-Edison.html.

Young, John. "Tim Burton Talks about *Frankenweenie*." *Entertainment Weekly* (ew.com). May 12, 2012. Accessed January 28, 2018. http://ew.com/article/2012/05/12/tim-burton-frankenweenie-interview/.

FRANKENWORDS

Not only has the Frankenstein story inspired new retellings, the very word itself has spun off into countless new forms. Whether tied to a specific character based on the doctor or the monster or used to describe anything cobbled together from spare parts, some variation of the prefix "Franken-" or suffix "-stein" (or "-enstein") conveys the idea. It's so pervasive that the term "Frankenword" has come to mean a new word formed by two or more other words. Here are just some of the new words and character names that owe their origin to Mary Shelley's creation:

Frankenstein complex	Frankenstrike	Frankie Stein
Frankenstein Jr.	Frankenteen	Franny K. Stein
Frankenbeans	Frankenthumb	Franky
Frankenbone	Frankenvirus	Frankie
Frankendoodle	Frankenweenie	Franken
Frankengoof	Franken Berry	Freightenstein
Frankenfish	Franken Girl	Finklestein
Frankenfood	Franken Roid	Frinkenstein
Frankenhole	Franken Stein	Blackenstein
Frankenhooker	Frank Enstein	Crankenstein
Frankenollie	Frank-n-Stein	Fangenstein
Frankenplant	Frank N. Stein	Fork-N-Stein
Frankenstitch	Frank-N-Furter	Phranken-Runt
Frankenstone	Frank-in-Steam	Stein
Frankenstorm	Frank and Stein	
Frankenstrat	Frank Stone	

INDEX

IMAGE CREDITS

PAGE 2 Allstar Picture Library Limited/Alamy Stock Photo. PAGE 4 Retro AdArchives/Alamy Stock Photo. PAGE 6 Collection Christophel/Alamy Stock Photo. PAGE 9 Courtesy of Everett Collection. PAGE 10 Courtesy of Everett Collection. PAGE 12 Art Collection 2/Alamy Stock Photo. PAGE 15 Lebrecht Music & Arts/Alamy Stock Photo. PAGE 16 Art Collection 3 /Alamy Stock Photo. PAGE 18 Shutterstock. PAGE 21 ARCHIVIO GBB/Alamy Stock Photo. PAGE 22 classicpaintings/Alamy Stock Photo. PAGE 25 World History Archive/Alamy Stock Photo. PAGE 26 Title Page of the First Edition of 'Frankenstein', 1818 (litho), English School, (19th century)/New York Public Library, USA/ Bridgeman Images. PAGE 29 Album/British Library/Alamy Stock Photo. PAGE 31 Album/British Library/Alamy Stock Photo. PAGE 32 Bettmann/Contributor/Getty Images. PAGE 34 Science & Society Picture Library/Contributor/Getty Images. PAGE 35 Science & Society Picture Library/ Getty Images. PAGE 37 Bill Waterson/Alamy Stock Photo. PAGE 38 Courtesy of Everett Collection. PAGE 39 Gamma-Keystone/Getty Images. PAGE 40 Pictorial Press Ltd/Alamy Stock Photo. PAGE 41 Courtesy of Everett Collection. PAGE 42 World History Archive/Alamy Stock Photo. PAGE 43 ullstein bild Dtl./Getty Images. PAGE 44 RGR Collection/Alamy Stock Photo. PAGE 45 Silver Screen Collection/Contributor/Moviepix/Getty Images. PAGE 46 John Kobal Foundation/ Contributor/Moviepix/Getty Images. PAGE 48 Courtesy of Everett Collection. PAGE 51 photo-fox/ Alamy Stock Photo. PAGE 53 Bill Waterson/Alamy Stock Photo. PAGE 54 John Kisch Archive/Getty Images. PAGE 56 Silver Screen Collection/MoviePix/Getty. PAGE 58 Shawshots/Alamy Stock Photo. PAGE 59 Courtesy of Everett Collection. PAGE 61 Photo by Mary Evans/Ronald Grant/Courtesy of Everett Collection. PAGE 62 Bettmann/Contributor/Getty Images. PAGE 63 Movie Poster Image Art/Contributor/Getty Images. PAGE 64 LMPC/Contributor/Getty Images. PAGE 66 Collection Christophel/Alamy Stock Photo. PAGE 69 Bettmann/Contributor/Getty Images. PAGE 70 LMPC/ Contributor/Getty Images. PAGE 71 Bettmann/Contributor/Getty Images. PAGE 73 Album/Alamy Stock Photo. PAGE 74 Pictorial Press Ltd/Alamy Stock Photo. PAGE 75 GAB Archive/Contributor/

Redferns/Getty Images. **PAGE 76** Paul Harris/Contributor/Hulton Archive/Getty Images. **PAGE 77**
RGR Collection/Alamy Stock Photo. **PAGE 78** Photo 12/Alamy Stock Photo. **PAGE 80** Courtesy of
Everett Collection. **PAGE 81** Shawshots/Alamy Stock Photo. **PAGE 82** Courtesy of Everett Collection.
PAGE 83 Photo 12/Alamy Stock Photo. **PAGE 85** Moviestore Collection Ltd/Alamy Stock Photo.
PAGE 86 Entertainment Pictures/Alamy Stock Photo. **PAGE 88** AJ P ics/Alamy Stock Photo.
PAGE 88 AJ P ics/Alamy Stock Photo. **PAGE 90** UNIVERSAL TV/RGR Collection/Alamy Stock Photo.
PAGE 92 Maximum Film/Alamy Stock Photo. **PAGE 93** Cinematic /Alamy Stock Photo. **PAGE 94** AJ
Pics/Alamy Stock Photo. **PAGE 96** Don Cravens/Contributor/The Chronicle Collection/Getty Images.
PAGE 98 Album/Alamy Stock Photo. **PAGE 99** Movie Poster Image Art/Moviepix/Getty Images.
PAGE 103 John Kobal Foundation/Moviepix/Getty Images. **PAGE 105** Hulton Archive/Stringer/
Archive Photos/Getty Images. **PAGE 106** United Archives GmbH/Alamy Stock Photo. **PAGE 107**
Jerod Harris/Stringer/Getty images. **PAGE 108** Jerod Harris/Stringer/Getty images. **PAGE 111**
Pictorial Press Ltd/Alamy Stock Photo. **PAGE 112** Moviestore Collection Ltd/Alamy Stock Photo.
PAGE 113 Allstar Picture Library Limited./Alamy Stock Photo. **PAGE 115** Photo 12/Alamy Stock
Photo. **PAGE 116 ABOVE** Allstar Picture Library Ltd/Alamy Stock Photo. **PAGE 116 BELOW** RGR
Collection/Alamy Stock Photo. **PAGE 118** Movie Poster Image Art/Contributor/Moviepix/Getty
Images. **PAGE 119** Classic Cinema Archive/Alamy Stock Photo. **PAGE 120** Robby Klein/Contributor/
Getty Images Entertainment. **PAGE 121** BFA/Alamy Stock Photo. **PAGE 122** FlixPix/Alamy
Stock Photo. **PAGE 125** © Hanna-Barbera/courtesy Everett Collection. **PAGE 127** Allied Artists/
Handout/Moviepix/Getty Images. **PAGE 128** Cinematic/Alamy Stock Photo. **PAGE 129** © Big Feats!
Entertainment/Courtesy: Everett Collection. **PAGE 131** Shutterstock. **PAGE 132** Pictorial Press Ltd/
Alamy Stock Photo. **PAGE 134** Maurizio Migliorato/Alamy Stock Photo. **PAGE 137** Pictorial Press
Ltd/Alamy Stock Photo. **PAGE 138** AJ Pics/Alamy Stock Photo. **PAGE 141** Cinematic/Alamy Stock
Photo. **PAGE 143** TCD/Prod.DB/Alamy Stock Photo. **PAGE 144** Larry Racioppo. **PAGE 147** Albert
L. Ortega/Contributor/Getty Entertainment. **PAGE 148** Shutterstock. **PAGE 153** Retro AdArchives/
Alamy Stock Photo. **PAGE 154** TM & Copyright © 20th Century Fox Film Corp. All rights reserved./
Courtesy Everett Collection. **PAGE 157** Garpax Records. **PAGE 158** Pictorial Press Ltd/Alamy Stock
Photo. **PAGE 159** Cinematic/Alamy Stock Photo. **PAGE 161** United Archives GmbH/Alamy Stock
Photo. **PAGE 163** Courtesy of Everett Collection.

ABOUT THE AUTHOR

Paul Ruditis is a *New York Times* best-selling author and pop culture addict who has written companion books for TV shows, including *The Walking Dead*, *Buffy the Vampire Slayer*, *Charmed*, *Star Trek*, and *The West Wing*. His diverse resume also includes original young adult novels, comic books, and novelty books for all ages. He currently lives in Los Angeles.

© 2018, 2025 by Quarto Publishing Group USA Inc.

This edition published in 2025 by Castle Books,
an imprint of The Quarto Group,
142 West 36th Street, 4th Floor,
New York, NY 10018, USA
(212) 779-4972
www.Quarto.com

First published in 2018 as *Vault of Frankenstein* by becker&mayer! books, an imprint of The Quarto Group, 142 West 36th Street, 4th Floor, New York, NY 10018, USA.

Castle titles are also available at discount for retail, wholesale, promotional, and bulk purchase. For details, contact the Special Sales Manager by email at specialsales@quarto.com or by mail at The Quarto Group, Attn: Special Sales Manager, 100 Cummings Center, Suite 265D, Beverly, MA 01915, USA.

10 9 8 7 6 5 4 3 2 1

ISBN: 978-1-57715-537-9

Digital edition published in 2025
eISBN: 978-0-7603-9685-8

Library of Congress Control Number: 2024952626

Publisher: Rage Kindelsperger
Creative Director: Laura Drew
Editorial Director: Erin Canning
Managing Editor: Cara Donaldson
Editor: Sarah O'Connor
Cover Design: Raphael Geroni
Interior Design: James Kegley

Printed in China